PAINTING *Animals*

that touch the heart ⟩⟩⟩

lesley harrison
ipsa

PAINTING *Animals*

that touch the heart >>>

Lesley Harrison

NORTH LIGHT BOOKS
Cincinnati, Ohio
www.artistsnetwork.com

ABOUT THE AUTHOR

For over twenty-seven years, Lesley Harrison has used pastel as the medium of her profession. In the process, she has dedicated a major portion of her life to pushing the limits of these pure pigment sticks.

Her wildlife subjects, domestic animals and her portrayal of horses are all well known for their lifelike realism and emotion. Her original paintings, commissions and limited-edition fine art prints are collected internationally by lovers of art and lovers of animals.

Her original pastel paintings have been showcased in books and have been featured in various publications, including *The Artist's Magazine*, *Art of the West*, *The Equine Image*, *U.S. Art*, *Wildlife Art News*, *InformArt* and *Equus*.

She has published forty-three limited-edition prints and seven open-edition prints, and has released a collector's series of plates produced and marketed by Danbury Mint.

She self-publishes her work as Harrison/ Keller Fine Art in Sutter Creek, California.

Lesley is a member of the Pastel Society of America and the Pastel Society of the West Coast. She has received the "People's Choice Award" at the Kentucky Derby Museum and had her work selected as part of the world traveling show for the Leigh Yawkey Woodson Art Museum's "Birds in Art" show.

While her pastel paintings receive awards in the few shows she enters these days, she spends much of her time jurying art shows for others or photographing people's animals and trying to find time to paint.

Her work is represented at the Harrison/Keller Fine Art retail gift store and gallery on Main Street in downtown Sutter Creek, California. Just look for the sign that says, "Animals That Touch the Heart."

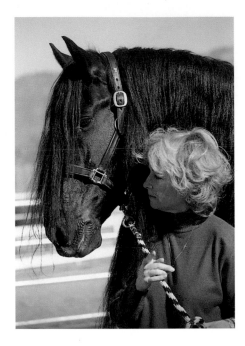

Other fine North Light Books are available from your local bookstore, art supply store or direct from the publisher.

06 05 04 03 02 5 4 3 2 1

Library of Congress Cataloging-in-Publication Data
Harrison, Lesley
 Painting animals that touch the heart / Lesley Harrison.—1st ed.
 p. cm.
Includes index.
ISBN 1-58180-131-9 (hc. : alk. paper)
1. Pastel drawing—Technique. 2. Animals in art. I. Title.

NC880 .H3555 2002
741.2'35—dc21 200202583

Edited by Jennifer Lepore Kardux
Cover design by Lisa Buchanan and Clare Finney
Interior design by Lisa Buchanan
Interior production by Kathy Bergstrom
Production coordinated by Kristen Heller

Art on page 2: *Willow*, pastel on velour paper, 16" × 12" (41cm × 30cm), private collection

METRIC CONVERSION CHART		
to convert	**to**	**multiply by**
Inches	Centimeters	2.54
Centimeters	Inches	0.4
Feet	Centimeters	30.5
Centimeters	Feet	0.03
Yards	Meters	0.9
Meters	Yards	1.1
Sq. Inches	Sq. Centimeters	6.45
Sq. Centimeters	Sq. Inches	0.16
Sq. Feet	Sq. Meters	0.09
Sq. Meters	Sq. Feet	10.8
Sq. Yards	Sq. Meters	0.8
Sq. Meters	Sq. Yards	1.2
Pounds	Kilograms	0.45
Kilograms	Pounds	2.2
Ounces	Grams	28.3
Grams	Ounces	0.035

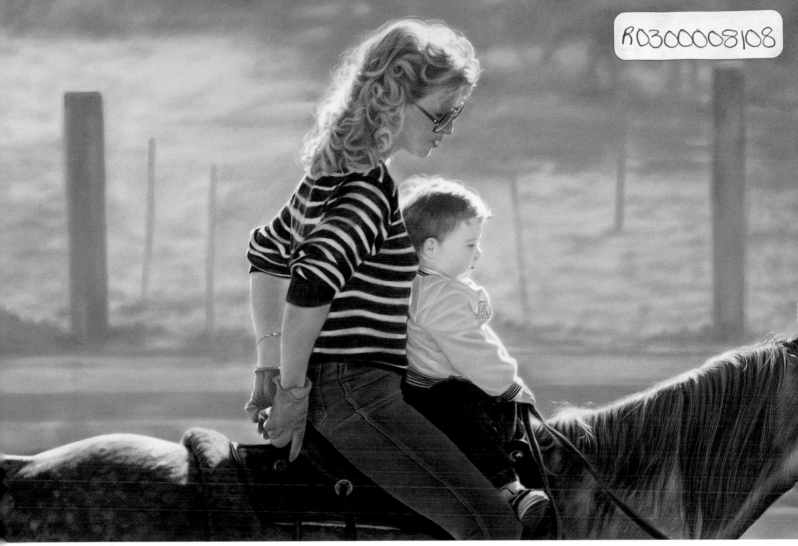

My Two Loves
Pastel on velour paper
18" × 24"
(46cm × 61cm)
Private collection

DEDICATION

To John, my wonderful husband, who is always there to help and encourage me when I bite off more than I can chew, or when I have a wild idea that I just know I can pull off (with his help, of course, when I get stuck halfway through it).

To my family, friends and "clients" (many of whom have become friends because of the art) who believe in me and have always been there to support my choices to do what I love. Your comments over the years about the "feeling" that you get from my paintings have helped me understand that feelings can be expressed and transferred from one person to another in a non-verbal way. From the bottom of my heart, I thank you and am so grateful to have you in my life. The greatest gift of my art has been the people that have come into my life because of it.

Also, to the wonderful animals that I have photographed and painted and gotten to know over the years, along with their caretakers. I thank all of you, animal and human alike, for your generosity and acceptance, and for all you have taught me.

ACKNOWLEDGMENTS

To my editor at North Light Books, Jennifer Lepore Kardux, for your patience, gentleness and mutual love of animals. And for sharing a personal story of courage and love for a pet when I was going through a painful time with one of my own.

To Libby Fellerhoff, who ignored the rules and let this book be on pastels instead of the more traditional mediums that are better known. Pastels are a beautiful way for artists to express themselves. Thank you for believing in pastels and in my ability to render them in a pleasing way.

TABLE OF *Contents*

➤ ➤ ➤ *Introduction 8*
Index 126

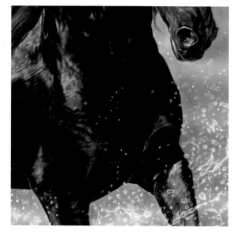

CHAPTER ONE: *Getting Started* ➤➤➤ *12*

Pastels
Paper
Other Tools
Studio Setup and Lighting
Research and Reference Material
Composition
Color
What Makes an Animal Painting Work?

CHAPTER TWO: *Big Cats* ➤➤➤ *28*

Aggressive Hunter
Tender Family Caregiver
Demonstration: Cat Eye
Demonstration: Cat Paw
Demonstration: Cat Fur
Demonstration: Canadian Lynx
Big Cat Gallery

CHAPTER THREE: *Wolves* ➤➤➤ *48*

Menacing Predator
Loyal, Sensitive Pack Member
Demonstration: Wolf Ear
Demonstration: Wolf Paw
Demonstration: Wolf Fur
Demonstration: Timber Wolf at Play
Wolf Gallery

CHAPTER FOUR: *Horses* >>> 66

Wild and Powerful
Gentle Giants
Demonstration: Horse Eye
Demonstration: Horse Legs
Demonstration: Horse Face
Demonstration: Horse Mane
Horse Gallery

CHAPTER FIVE: *Dogs and Cats* >>> 82

Portraying Your Pets
Demonstration: Cat Whiskers
Demonstration: Dog's Brown Eye
Demonstration: Cat's Blue Eye
Demonstration: Dog and Cat Portrait
Dog and Cat Gallery

CHAPTER SIX: *Baby Animals* >>> 102

Babies vs. Mature Animals
Demonstration: Baby Bunny
Demonstration: Sea Otter Pup
Demonstration: African Lion Cub
Demonstration: Gosling
Baby Animals Gallery

As an artist I have chosen to paint animals (because I love them) for years. The number of years depends on where you'd like to start counting. I've made my living painting them professionally, in pastel, for almost thirty years. I've been drawing, sculpting (if you want to count that plaster of Paris palomino horse head that my mother still has from second grade) and painting animals for most of my life. I experimented in just about every traditional medium there is until I fell in love with pastel and the "look" I could achieve with it.

You could say I was born loving animals and art. You probably were, too, or you might not be reading this.

All artists evolve differently, just as all people do. We are constantly influenced by the people and things around us. It's interesting to trace that back to our childhoods.

FAMILY INFLUENCES

My parents, of course, have had a huge influence on me. I am blessed in that they have always been, and still remain, two of my greatest fans. My mother is very artistic, so it's obvious which side of the family the "gift" came from. She's also a great animal lover, and both of my parents brought me up with lots of exposure to all of the arts.

My dad and mom, who are in their eighties, still come to my exhibitions and show up whenever we need them to hang paintings or pour wine when we have our own shows out of our gallery and studios. What greater support and encouragement could a daughter have? For years I was told by the "experts" that a woman artist painting animals (and especially horses) in pastel would never make it in the art world. I never believed them. I'm sure that is at

least in part because I learned to believe in myself at a young age. After all, my parents always did! Their encouragement and belief in me has been a huge influence on my art.

Another great thing that I have in my life is a husband that encourages me, believes in me, brainstorms with me, loves animals and rides horses, too. We have great animal adventures together, making life so fulfilling and fun. Whether it's pushing cattle in the driving snow at a friend's ranch in Montana or watching and photographing a pack of (captive) wolves on a frozen lake, he loves it every bit as much as I do. But that makes sense, don't you think? My best friend loves what I love and we get to share the joy of it all together.

ANIMAL INFLUENCES

The animals! Where to begin telling how they have affected me and my art?

I saved my money from babysitting and odd jobs to buy my first horse when I was fourteen years old. I begged my parents for a dog from the shelter and we always had cats, rabbits and birds.

I grew up surrounded by animals. I read horse books about how to train horses, slept and ate with my own horse, and found the love of a lifetime. My dog, my horse and I had so many happy, carefree times together during those years.

I would tie my horse or dog to the fence and sit with them for hours, sketching them. They weren't very happy about it, and that helped me learn what a great tool a camera could be to capture action or make an animal "stand still." Even back then I wanted my drawings to be realistic and portray the animal as he really was.

Owning animals and being around them all of my life has had a big influence

on my art. You can't help but get to know them by handling them every day. I was unconsciously fulfilling one of the rules of art—paint what you know. The simple, mindless act of grooming and looking at animals has to make a huge difference when it comes time to represent them on paper. Some of the huge boarding stables where I have kept my horses over the years have had other animals that have caught my artistic fancy. There are subjects everywhere! All we have to do is "see" as we go.

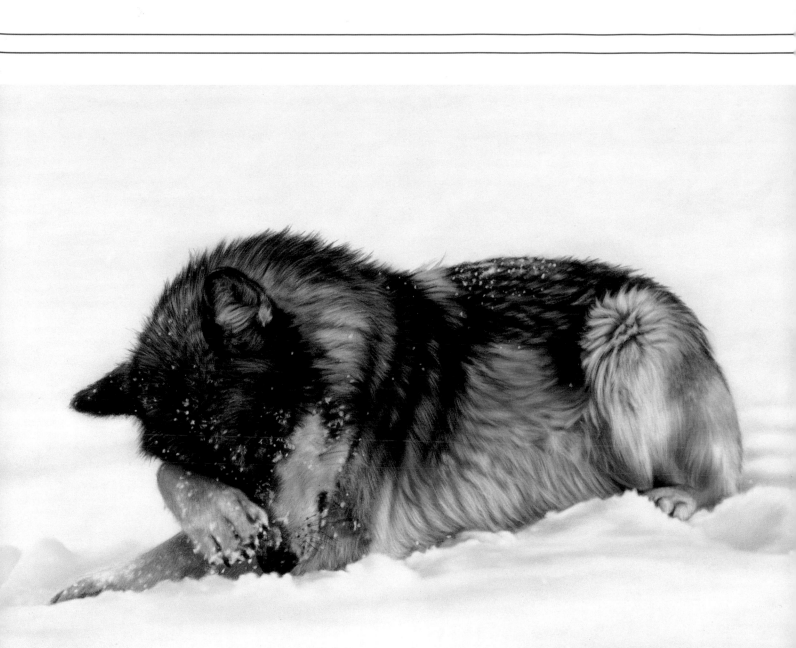

Snow Flurries
Pastel on velour paper
13" × 20" (33cm × 51cm)
Private collection

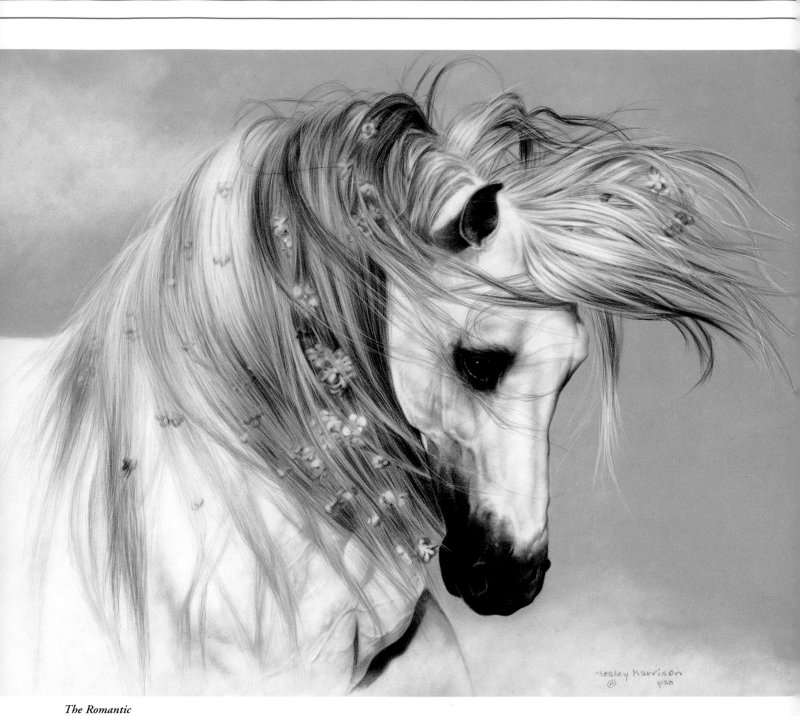

The Romantic
Pastel on velour paper
16" × 20" (41cm × 51cm)
Private collection

EXPRESSING EMOTION

Even after all these years of being around animals, my passion has not diminished. I still stand in awe of these wonderful creatures.

Some of the greatest compliments I receive about my art come from non animal lovers who say to me, "I don't even like animals, but I must have this painting!" I really believe it's because it makes them "feel" something that they want to take with them. The fact is, animals are beautiful, like flowers are beautiful: You don't have to love them to appreciate their beauty.

Painting a feeling is such a nebulous, personal thing to attempt that I am so thrilled and honored when someone "gets it." It's powerful to be able to share a feeling visually, without words, and have people understand the message. It's one thing to capture the beauty of an animal, but it really makes a painting work if you can capture the individual feeling and personality of the animal as well.

It might be the personality of a blind stallion that is still being shown or about the deaf horse that no one could train until a deaf trainer taught her sign language. Or maybe it's trying to show the wonderful loyalty and obedience of a dog that will wait outside in the snow while his owner is inside. Of course, all of my subjects don't have lives or stories as dramatic as this, but they "speak" to me in one way or another as I try to give them life on paper or canvas. My attempts to portray them will continue to be worked on, because after all, "painting a feeling" is a huge and wonderful challenge, never to be fully conquered, rarely achieved, but always worth the effort!

TELLING A STORY

Animals cannot speak to tell their stories, so some people assume they have no feelings. Artists can help "tell their stories" with more than words. In order to do that, we need to become technically proficient enough so that people don't get "stuck" on whether the anatomy or color or muscling are accurate. It's like a very talented piano player who has practiced for many, many years. As you listen you don't find yourself being jarred by the mistakes. Instead, you get lost in the feeling and the beauty of the music. The technical skill should seem so effortless that people get lost in the feeling and the beauty of the painting.

WHAT YOU WILL LEARN

I hope what you learn from this book is threefold. First, to express yourself. Remember, you are the gift! Every day that you paint you are learning more about yourself and being able to free yourself up to visually express what is important to you. It takes time, so be patient. A little added to a little eventually can become great.

Second, that there are many ways to render a medium, like pastel, beyond what we are taught or see others do. Learn to conquer pastel and get it to work for you. Pastel can be very realistic and produce beautiful paintings, and the learning is part of the joy.

Third, the thrill of having people look at one of your paintings and "get" what you were trying to say without you having to step in to translate it for them.

So, enough talking! Let's have some fun and get started.

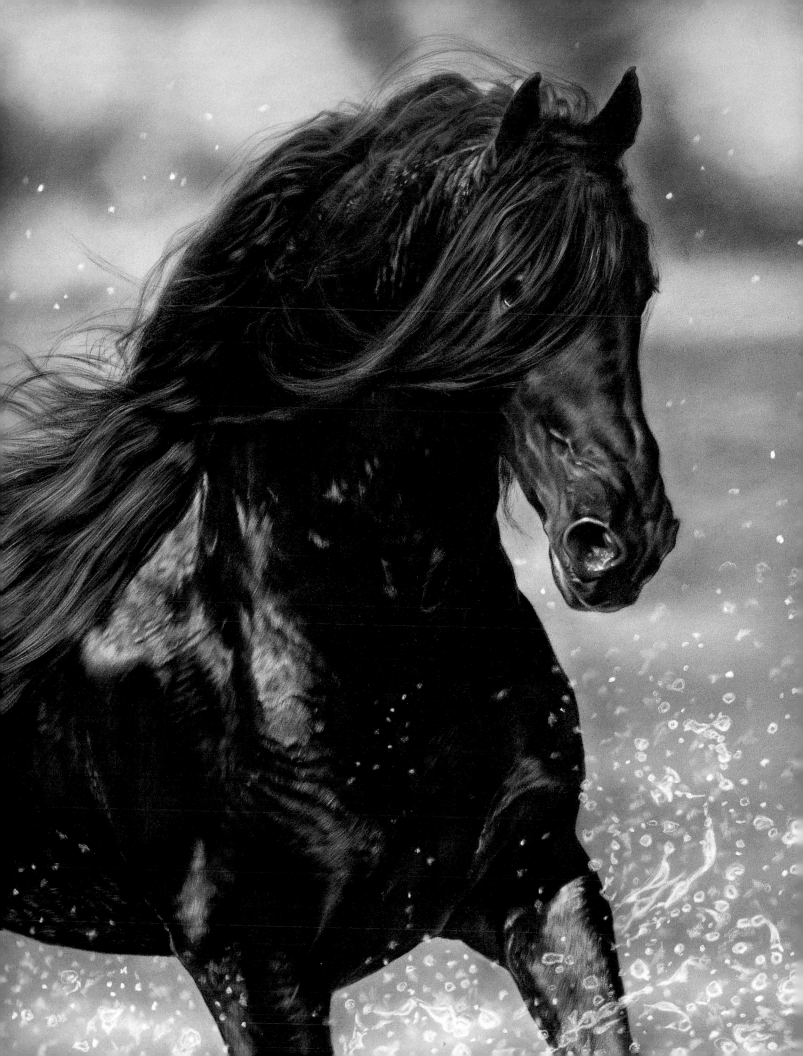

Getting Started

Wouldn't you love to work in a medium that not very many people use and have your work stand out as "different"? Pastel can do that for you. Not only that, but it's fun and easy. No brushes to learn how to use or clean, no colors to mix together on a palette, no set up time or clean up afterward. All your colors are already mixed—just choose one! It really is that easy. I can show you how to do the rest because I've been having fun with pastels for almost thirty years.

Remember the chalk and crayons you used in school? Didn't you just pick them up according to whim and use whatever color seemed right for the occasion? If you were motivated to draw as a young child, you probably used most any surface that you could find to work on—some maybe more appropriate in adults' minds than others. With pastel you can still do that. Any surface that has a bit of "tooth" or some texture to hold the color will work, and you're off and running.

If you're at all like me and don't feel comfortable with brushes and paints, pastels may just be what you'll fall in love with, too. Or, you may be an accomplished oil or watercolor painter and want to try something different. If one of your strong points is drawing, you are probably a good candidate to try pastels. Drawing was my first love and still is, and pastel just seems like the next step from using pencils, giving you glorious, rich color at your fingertips!

Where Such Majesty
Pastel on velour paper
25" × 19" (64cm × 48cm)
Private collection

Pastels

It is a great time to try pastels for your first experience or go back to pastels if you have been away from them for a while. There are now more options for a pastel artist than ever before, thanks to a resurgence of interest in this wonderful medium.

EXPRESSIVE MEDIUM

It makes me smile when I think back twenty-eight years ago to my first experience with pastels. I was living in Arizona at the time and was wandering through an art store in Tucson when I spotted a book with a fabulous painting of a horse on the cover. On closer examination, it was a how-to book on painting horses. I'd been drawing and painting horses for years, and these were really good! After spending more time with the book, I realized that I loved the soft, real quality that the artist achieved with pastels on velour paper. I was hooked!

Up until that time I had worked mostly in pencil, which I loved. I'd tried just about every other medium available, including oil pastels, but always went back to pencil. I found all the other mediums frustrating for what I wanted to express—the "realness" of an animal when I was up close enough to see and touch him. I wanted other people to see and feel what I did as I experienced the privileges that come from being allowed to get up really close to animals that most of us only experience from a distance or behind bars. (The animals, not us!)

The really great thing is that even with my little eighteen-stick starter set of Grumbacher pastels (I had to order them, very few art stores carried pastels then) I knew as soon as I tried them that I had found a way to express this realness. I encourage you to try them, too. You just might fall in love!

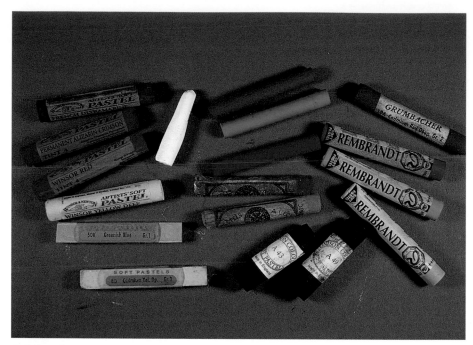

Soft Pastels
This is a grouping of the pastels I use to start and build my paintings. I made the white pastel myself.

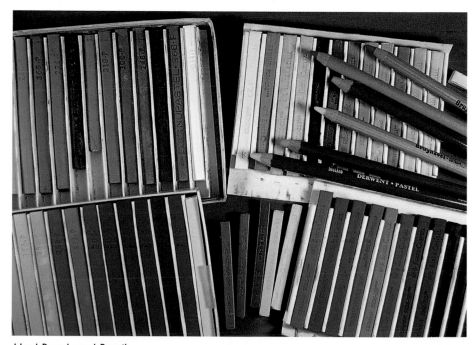

Hard Pastels and Pencils
This is a grouping of the pastels I use for detailed finish work.

WHAT ARE PASTELS?

Pastels are the most permanent of all art mediums because there are no liquid binders that might cause them to darken, fade, yellow, crack or blister with time. There are pastel paintings that were created in the sixteenth century, and their colors are still as bright and vivid as the day they were painted.

The name "pastel" comes from the French word *pastiche* that describes how pure, powdered pigment is ground into a paste with a small amount of gum binder and then rolled into sticks. With a small amount of research you can even learn to make your own pastels.

SOFT PASTELS

Soft pastels can be used alone or in combination with many other mediums. They can also be used on many different surfaces as long as enough tooth exists or is created to help them adhere permanently to the surface. Remember, a pastel stick becomes powdered pigment again as soon as you rub it on something. The binder is simply there to give us a means of shaping it into a stick so we can use it.

Girault makes the pastels I use the most. These pastels have strong browns and earth tones, their greens are good, and they have some really nice blues. These are the colors I use the most, so of course it's what I shop for in a new set. They are a nice medium-soft grade that goes onto velour paper nicely.

I wish the animals I painted were pink, purple, orange and red (because I really do love color) but since I don't paint many birds, I need sets strong in browns and grays. Either that or I need to become an abstract artist so all of those wonderful colors can be used!

Sennelier from France makes a lustrous set of pastels that are generally quite soft and quite expensive. I wanted them for years and when I finally got my first set, found most of them generally a bit too soft for my velour paper. But occasionally I find the perfect color that I need in this set that no one else has.

I still love my **Grumbachers** (I eventually got a whole set), and the **Rembrandt's** are harder than some of the others but are nice to have. I really like their range of grays.

Unison is a newer brand of pastels that are very popular with pastel artists. They are soft with some wonderful blue-greens that are hard to come by.

Daler-Rowney and **Winsor & Newton** make whole sets of soft pastels, too. There is a new company called **Great American Art Works**, and I hear a company in Australia produces some nice sets called **Art Spectrum.**

I haven't even begun to tell you about **Schminckes**, Diane Townsend's wonderful handmade pastels, or **Yarka** pastels from Russia. The list goes on and on.

HARD PASTELS

I love detail and therefore use a lot of hard pastels for the finish work in my paintings. Hard pastels come in sticks, or encased in wood as pastel pencils.

My very favorites are **Prismacolor's Nu Pastels.** They have a range of almost one-hundred different colors and can be sharpened for detail without breaking.

Conté also has a set of smaller, hard pastels that I use occasionally. I also love **Derwent's** wonderful pastels. These are both great pastels to work with for very fine details.

Paper

I work on about three different types of paper, but there are many different options, and I encourage you to experiment.

VELOUR PAPER

I always go back to velour paper, which can be bought at most art supply stores and through mail-order catalogs. After all these years, velour paper still gives me the effect I want most. I often joke that if I knew I was going to become a professional artist, I never would have fallen in love with velour paper. It's quite delicate to work on, have framed and ship. But the softness and reality that it brings to living subjects is so beautiful that I can't resist it.

Velour paper is wonderful, but every wonderful thing has a downside. The difficult thing about this paper is that you really can't erase on it. That simply means that you do all your sketches and planning on another piece of paper that is more forgiving and then transfer it to the velour. You can use carbon paper or artist's transfer paper.

SANDPAPER

Another paper I enjoy using is a fine-grade sandpaper, which can be bought in most art supply stores and through mail-order catalogs. Sandpaper is fun to work on because it "grabs" the particles of pastel and hangs on to them! I prefer the velour paper, though, because I can achieve more layers of pastel and finer detail.

PASTEL CARD

Another paper that I've tried and really enjoy is pastel card. It's a little less grainy than sandpaper yet still has a lot of tooth. It doesn't "eat" as much pastel as sandpaper and is fun and quick to work on, but it will not allow you to achieve the same amount of detail as you can on velour paper.

CAN YOU "FIX" PASTEL PAINTINGS?

Spraying fixative on your pastel dulls the color and detail. If you do your paintings on velour paper, the pastel sinks down into the nap of the paper and won't fall off like it can on other papers.

However, always be careful not to drop your paintings. Dropping a painting causes the pastel to fall from the paper's nap, and will damage your painting.

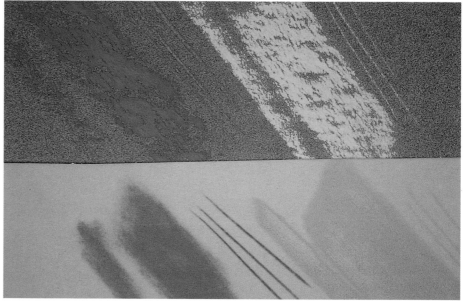

Varied Effects
Hard and soft pastels look quite different depending on the paper on which they are applied. The sample at the top shows pastel applied on sandpaper. The sample below that shows pastel applied on velour paper. (The thinner lines are made with hard pastels; the wider lines are made with soft pastels.)

Other Tools

SHARPENERS

To sharpen your hard pastels, use sandpaper blocks, which you can buy at art supply stores, or mount a piece of sandpaper from a hardware store on a piece of wood. This way, you have four sharp edges. You can sharpen your pastel pencils to a point for your fine lines and detail.

RAZOR BLADES

It's easier on your pastel pencils and your time to sharpen them with a razor blade. You will jam up your pencil sharpener if you try to sharpen pastel pencils because they are too soft and break off inside the sharpener. I got tired of always dismantling my electric pencil sharpener and fixing it from having loose pastel gumming it up.

BLOWER BRUSH

The blower brush is used to blow loose pastel off of different parts of your painting, usually in its initial stages. Always blow the dust away from you as you work.

BLACK CONSTRUCTION PAPER

When working with pastels it is important to protect your work as you go. To avoid smudging, place a piece of black construction paper over the areas of your painting that are already started. (Black paper will not cause a glare from your lights and will be easier on your eyes.)

MASKING TAPE

I use masking tape to position protective paper in different places over and around the painting I'm working on.

BE SAFE

Many of the pigments used in pastels can be toxic to humans. For more detailed information, consult the pastel manufacturer, or *The Artist's Handbook of Materials and Techniques* by Ralph Mayer, revised by Steven Sheehan (Viking Press, 1991).

- Never eat while painting. Do not transfer pigment to your mouth.
- Wash your hands with soap and water off and on as you paint, and always before eating.
- Wipe loose pastel from your hands whenever you think of it. Wet wipes work well.
- Cover your fingers with plastic finger "cots" (similar to thin, plastic gloves, but they only cover your finger).
- Apply special hand cream before painting (check with your local art supplier for this barrier-type cream).
- Wear a face mask (similar to those worn by dentists) to avoid inhaling pastel dust.

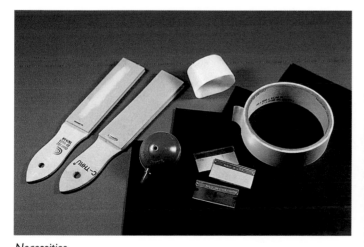

Necessities
Sandpaper blocks, blower brush, razor blades, masking tape and black paper.

Painting in Process
Use black paper to protect your art as you work.

Studio Setup and Lighting

LIGHTING

I'm not one of those artists who is rabid about what kind of lighting to use. There are a lot of great options, and you can find out about them through catalogs, art supply stores or talking to other artists. We all have our preferences and are happy to share what we have learned.

I have two studios that I work in. One is "in town" and is a large space, with windows and two huge skylights. The studio I have at home is small and cozy with all the windows blocked off because of the glare. I light candles as I work in the home studio and use a light that combines fluorescent and incandescent bulbs on an adjustable arm. The combination of bulbs helps to balance the light so your colors are true.

I don't feel that my work is any different or inferior because the lighting and studio spaces are so different from each other. As with everything, find what works for you and never think you have to have the best or most expensive thing out there in order for it to work well.

SETUP

In town, my drafting table and pastels are set up under one of the big skylights. The studio is large and bright and roomy, with overstuffed couches, chairs, shelves full of research books and a lot of teddy bears. It's bright, busy and fun.

My home studio is warm, cozy, peaceful and quiet. I work where my mood sends me.

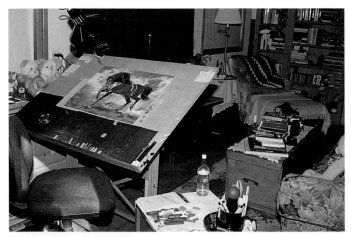

Home Studio

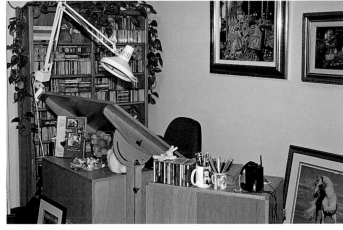

Town Studio

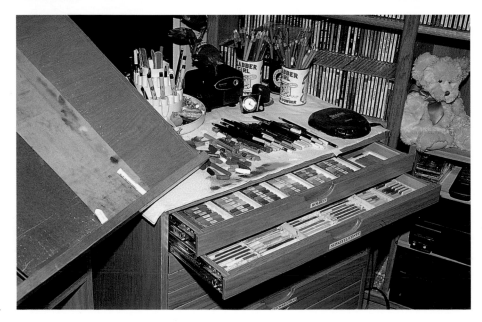

Supply Organizer

Research and Reference Material

Gathering and using reference material is the most exciting part of doing a painting. It's like packing for a trip—the possibilities are limitless.

The first thing to remember is to paint what you love! There are so many choices out there, and no one can tell you what you should paint. If you can't figure out immediately what you'd like to paint, examine what your lifestyle and actions tell about yourself.

Make yourself familiar with your subjects. Gather books and articles about your subjects. Build up your reference photos. The odds are against going out in the wild and finding a lion, tiger or bobcat to photograph, so make acquaintance with zoos, wildlife parks and private owners of exotic animals. They have years of experience and will help you understand the animal you are painting.

TAKING GOOD REFERENCE PHOTOS

I have found that a zoom lens in the range of 80–200mm is perfect for photographing most animals. If you choose to paint animals, as I have, be conscious of the fact that animals can be challenging to photograph. They have good and bad days like we do, and if it isn't your own animal, that may make it more difficult. Make sure to respect them and the owner or caretaker that is allowing you to be there, whether you are photographing puppies or tigers.

If your passion is wild animals, remember that they are never truly domesticated as our house cats and dogs are. Always be careful and never risk the animal, the keeper or yourself to get a good photograph.

USING YOUR REFERENCE PHOTOS

It's rare that you will have a photo which is just to your liking. But most reference photos have possibilities—that's what is fun. Find one that appeals to you, then start brainstorming on how to use it to create a piece of art. Look through your other reference photos to see if you can combine images in some way: adding a new night sky behind your subject, placing another subject in the composition, etc.

Whether you design a painting in your head and then go out after the reference material or whether you use the reference material to give you your design is up to you. Do what works best for you.

Once you have an idea and reference materials, sketch different compositions until the positioning looks right. Once you have a composition you like, transfer it to a sheet of velour paper and start painting.

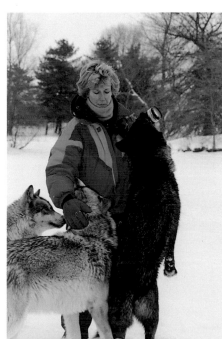

Taking photos of wolves in the snow.

A playful pause during a photo shoot.

A quiet moment after chasing and photographing an Andalusian stallion.

DO SOMETHING DIFFERENT

I'm not sure if it's because I've painted for so many years or if I've always been this way, but I'm a believer in doing something different so people will notice your work. I'm not talking about something bizarre—I'm thinking more of giving your painting a different slant or different approach from the norm, which simply means, paint it the way it appeals to you.

You can do that by using a different angle, using colors that will grab the viewer's attention, choosing an unusual or striking background or painting something close-up. If you're doing a commission of somebody's child or animal, make sure that "different" is something that agrees with them. They may have something very traditional in mind.

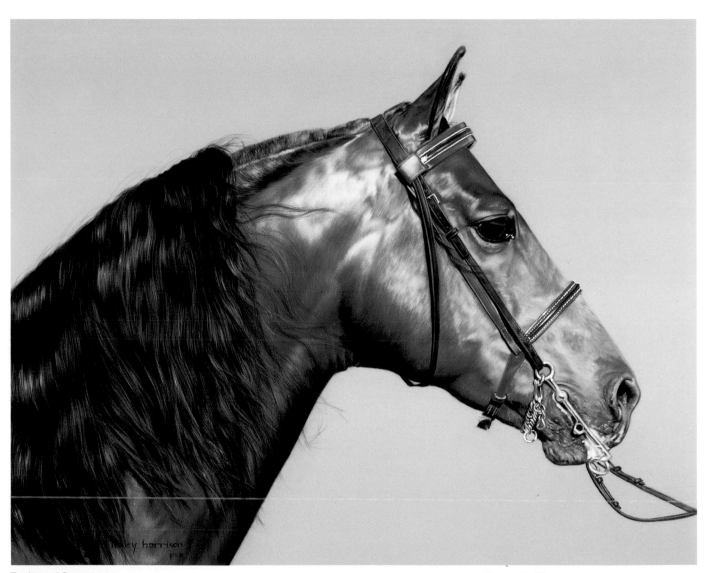

Traditional Portrait
This is a traditional approach to painting a simple portrait of a gorgeous Morgan stallion. It is a simple profile—head and neck. Many buyers prefer the traditional, predictable portraits of their or others' animals. I have done traditional portraits for so many years now that I choose to find some unusual way to paint them unless the owners ask for a classic stance.

I didn't know who owned this horse, because I saw him at a horse show with a lot of other horses, but this painting sold to some perfect strangers who loved it. Hopefully the owners would have, too.

Morgan Stallion
Pastel on velour paper
18" × 24" (46cm × 61cm)
Private collection

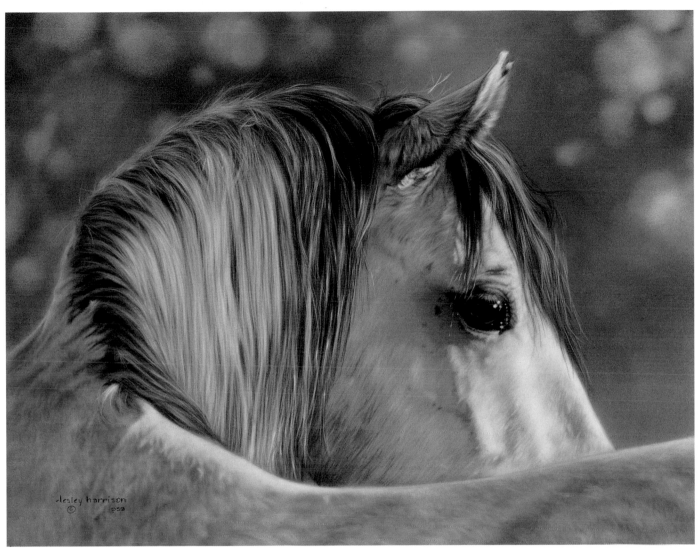

Unusual Angle

This image gets a lot of attention because of the different angle. We don't usually look at a horse from this viewpoint. It causes people to zero in on his eye and the feeling they get from this horse. I painted him this way because he was so sweet and calm and I wanted to portray him that way, in addition to showcasing his gorgeous eye.

The Kindness in His Eye
Pastel on velour paper
13" × 17" (33cm × 43cm)
Private collection

PAINT YOUR RESPONSE TO THE WORLD

In wanting to do something different, I wouldn't recommend going out and looking for some kind of gimmick. Instead, learn to read your own responses to the world around you and then give that gift through your art. There will always be other people who will respond just as you do to something that motivates or touches you strongly.

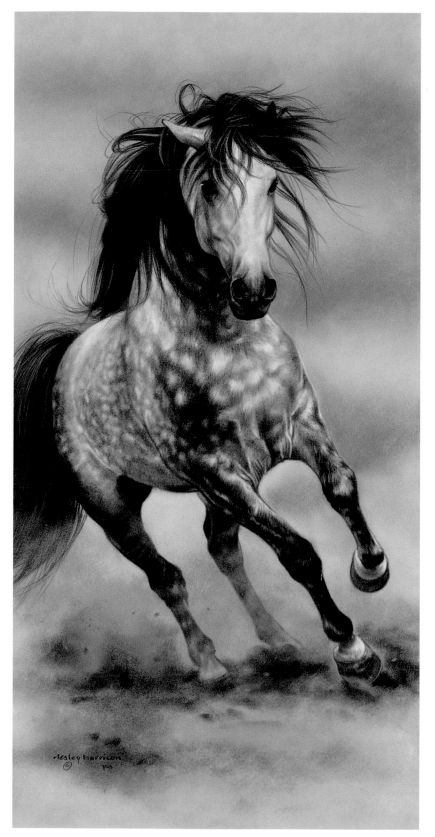

Minimize the Background

You can draw attention to your painting by minimizing the background. This will have the effect of making the subject stand out without distractions. I thought this dapple-gray was strong enough to stand alone without the help of a background. It also was a sketch to experiment with perspective before I took it to a larger, finished painting.

Glorious Gray
Pastel on velour paper
20" × 10" (51cm × 25cm)
Private collection

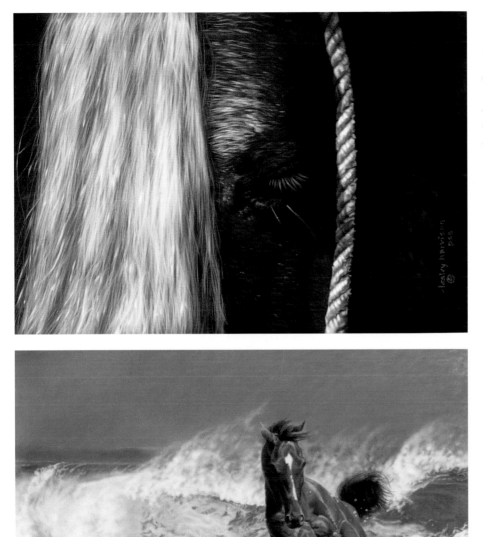

Close-Up View

Sometimes it takes people a little time to figure out what is actually going on in this painting because they're not used to seeing just a portion of a horse so close. Close-ups cause viewers to spend some time with something that they might not have noticed. This is the mustang stallion from page 68, standing with a twisted rope for a halter and going to sleep.

Eyelashes
Pastel on velour paper
11" × 14" (28cm × 36cm)
Private collection

Unusual Background

The danger in pushing the limits is that sometimes your paintings may not work out. But in always exceeding and pushing beyond where you are artistically, you stay challenged, excited and terrified of each new painting. That's a good thing! I find if I'm bored and a painting looks easy, I tend to get sloppy. Pure terror has a wonderful way of keeping you awake and on your toes!

I never tried to paint a horse in the water (I've done plenty where a horse runs along the beach) and was not sure if the man who commissioned me would like it, but I tried it anyway, and it worked.

Exuberance
Pastel on velour paper
16" × 20" (41cm × 51cm)
Private collection

Color

Have you ever walked into a room where the colors made you feel edgy or irritable? Some colors are naturally pleasing and calming while others have exactly the opposite effect. Since this book talks about creating a mood with your paintings, color is a major topic to consider.

COLOR AND MOOD

Close your eyes. Visualize red. Does it make you feel excitement? Speed? Heat? Visualize green. Is it soothing? Rich? Inviting? Try purple on. How about blue, brown or bright yellow?

The colors we use in a painting can make a viewer feel bad or good without them even knowing why.

Light yellow

Dark yellow

Orange

Warm red

Cool red

Brown

Olive green

Dark green

Sky blue

Medium blue

Dark blue

Black

Basic Color Palette

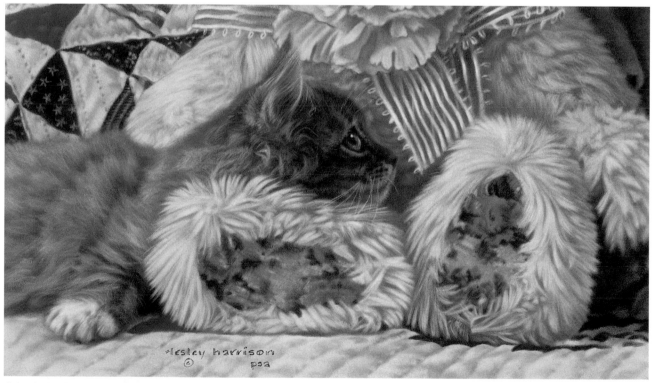

Color Invites You Into the Painting
The predominant colors in this little painting of our kitty, Choco, are warm and soft. The tan, pink and peach colors invite you into the painting and make you feel good. The harsher colors (navy blue and red) are in the background and don't intrude on the main feeling of the painting.

Precious Friends
(or Choco and Twinkle)
Pastel on velour paper
8" × 14" (20cm × 36cm)
Private collection

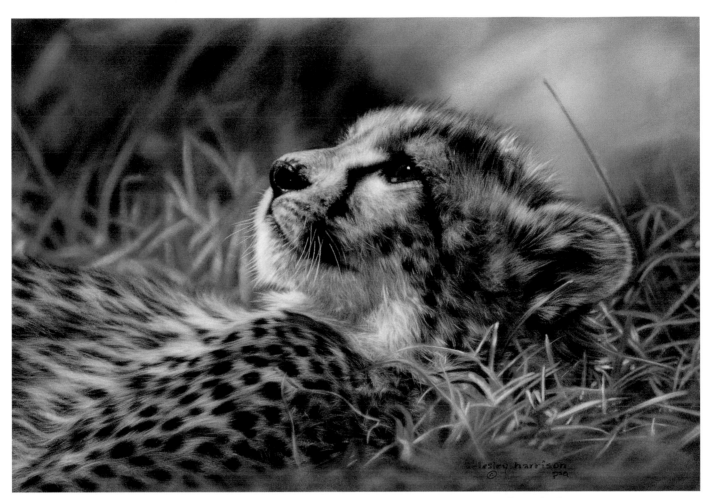

Color Stirs Memories

This painting brings back happy memories for me. When I was a child I used to lay on my back and look at the clouds, trying to imagine what animal the different clouds looked like. Part of what helps stir this happy memory is the far-off look in the cheetah's eyes and the warm browns against the cool greens. If I had placed the cheetah in a field of dried grass or dirt, the painting wouldn't have had the same peaceful effect.

Since warm colors tend to come toward the viewer and cool colors recede, a painting becomes more interesting if both are used. If the artist uses only warm or only cool the effect can be flat, with nothing to bring life to the piece.

This painting brings the cheetah to life with warm browns in the foreground; background colors bring the coolness that the eye wants to see in contrast. The warm colors bring the cheetah forward and make the viewer pay attention to him while the greens relax the eyes and let them focus on the cat.

The same effect can be used in shadowing an object or animal. The feeling around an animal lit by the sun in contrast to the cool shadow makes the animal seem more realistic. To slavishly copy photographs does not always give you these results. It helps to remember some of these things so you can make choices as you paint.

Watching Clouds
Pastel on velour paper
12" × 16" (30cm × 41cm)
Private collection

What Makes an Animal Painting Work?

As artists we have lots of choices. We know we want to paint a particular image because something inside of us responds to it. We need to be creative and think about what is most important to us about this image.

The paintings on this and the facing page are examples of the three points you should keep in mind when painting animals that touch the heart of your viewer.

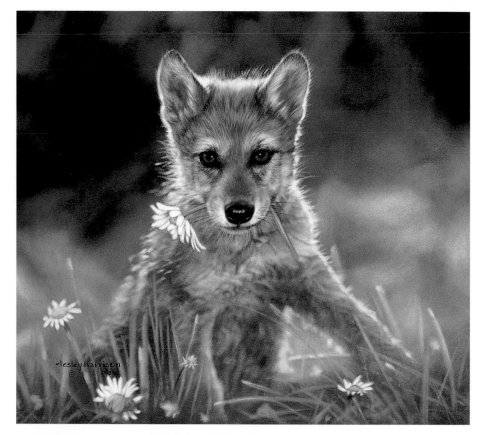

Is the Subject Believable?

I had some darling photographs of a wolf pup all by himself. I was working on a calendar of wolves for a company and wanted to paint this little guy. We had just gotten home from a summer vacation in Idaho and the daisies were everywhere! I loved them. So instead of just having a wolf pup in the grass, I painted him with one of the daisies in his mouth. Believable, yes, and it makes the painting a little more fun.

Chasing Daisies
Pastel on velour paper
12" × 14" (30cm × 36cm)
Private collection

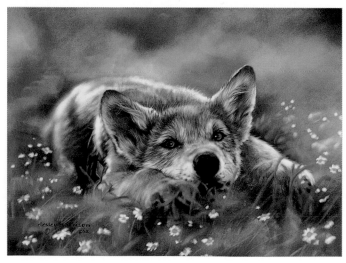

Is the Subject Too Intimidating?

Not this one! After I finished this little guy, I hung the painting in our showroom. We waited for people to come to him as they went around the room looking at artwork. Without fail they smiled, giggled or laughed out loud. What fun to watch that kind of response!

Without a Care
Pastel on velour paper
12" × 14" (30cm × 36cm)
Private collection

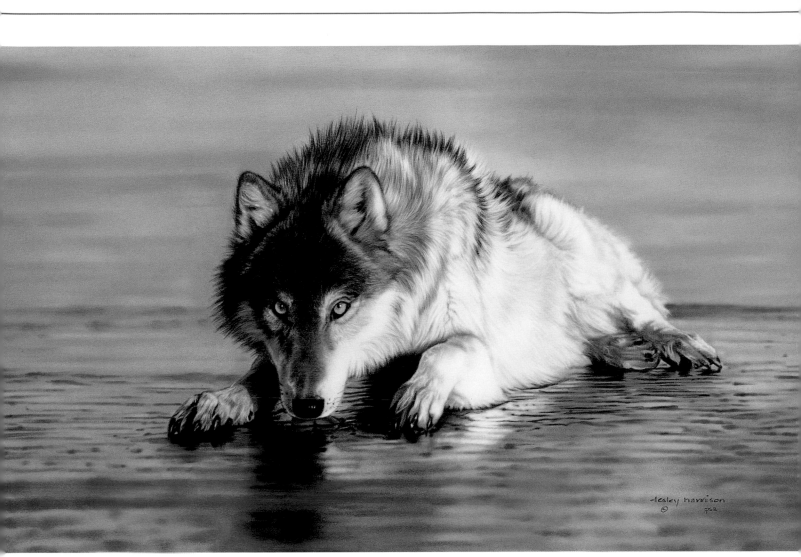

Do the Colors Work Well Together?

This painting of a wolf licking the ice has wonderful colors that play well against each other. The color balance is pleasing to the eye. The wolf is in warm tones, including his reflection, and that is played against the cool tones of the blue ice.

Popsicle
Pastel on velour paper
12" × 20" (30cm × 51cm)
Private collection

Big Cats

CHAPTER TWO ➤ ➤

The big cats that we are all a bit in awe of can be painted a couple of different ways—as aggressive hunters, which they have to be to survive, or in the tender moments they have among themselves.

You won't need any expert to tell you which is which. All that has to be done is pay attention to your feelings as you go through photographs or as you sit at a zoo or wildlife park watching them. If you respond with fear or revulsion, know that your viewer will feel the same. If you feel happy and touched by what you see, so will your viewer.

This chapter will show you how to develop your technical skills by practicing with different types of cats. This will help you convey feelings to your viewers without words.

It's fun! And I can't tell you what a thrill it is when someone comes into our showroom and stands in front of one of my paintings with tears streaming down her face. Or when someone stops to marvel at the feeling a certain painting evokes.

They say that in a gallery a painting gets one-tenth of a second to catch the attention of the person walking past. What a great challenge! Let's get started.

Icy Whiskers
Pastel on velour paper
24" × 12" (61cm × 30cm)
Private collection

Aggressive Hunter

I often work with big cats so I'm not a good person to judge whether they are looking aggressive to viewers of art or not. The lesson I'm learning is to remember back to when I was first around cats and didn't understand their habits or body language. Generally, most of us choose paintings that make us feel good as opposed to those that scare us.

The painting below shows two tigers playing. It makes me smile when I look at it because the one tiger has accidentally picked up the tail of the other tiger. The second tiger is warning him: "Excuse me, but that's my tail and I'd appreciate it if you would drop it right now!" The second tiger says "Oops," and of course drops it. All cats love to tussle and play with each other, be they house cats or tigers in the wild.

But people who are not around big cats very often get concerned about the second tiger in this painting, thinking that he is about to be injured or killed.

This kind of subject does not touch the heart! Most people don't want it on their wall unless they know tigers well. And that narrows down your possibilities of finding a home for it. If you need to please and sell, aggressive subjects are much harder to market.

A Tiger By the Tail
Pastel on velour paper
16" × 27" (41cm × 69cm)
Private collection

Tender Family Caregiver

Painting the tender interaction of wild animals can be quite fun. It is a privilege to see their private moments of playing or nurturing. The big cats raise their families, hunt to feed them and teach them hunting skills. When the cubs tussle and play with each other they are developing skills and a hierarchy that they will use later in life for survival. All of these things are wonderful subject matter. Sleeping babies are always so soft and sweet looking.

This painting is titled *Contentment* because that was the strongest feeling I got from it as I painted. The looks on their faces seem so content in the midst of the tough world they live in, where every day is a test of survival. How wonderful to be able to stop the clock and capture a moment of bliss.

Contentment
Pastel on velour paper
15" × 12" (38cm × 30cm)
Private collection

Eyes are the most fun and rewarding part of anything I paint. I always hold them out as a treat to myself after I have spent time doing other things that are essential (but not as much fun) to the painting.

Eyes are beautiful and expressive and can set the mood for our paintings. Just as we show emotion through our eyes, animals' emotions can be read in their eyes.

MATERIALS

Surface
Gray velour paper

Soft Pastels
Golden yellow

Hard Pastels
Black
Brownish gray
Olive green
Reddish brown
White

▶ **STEP 1:** *Complete the Sketch*

The gray paper will serve as the predominant undercolor for this snow leopard.

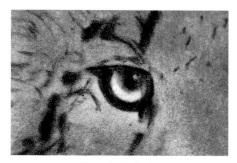

▶ **STEP 2:** *Define the Black*

Use a sharpened black hard pastel to go over your sketch marks, giving them more shape and substance. Leave a small paper-colored area where you will want to put a light reflection in later.

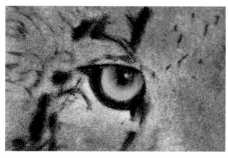

▶ **STEP 3:** *Apply the Basecoat*

I thought once that it would be nice to skip this step and just jump to the fun stuff, but I ended up with a flat, uninteresting painting. This step is essential! Use a nice, golden yellow soft pastel as the iris color.

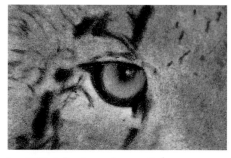

▶ **STEP 4:** *Begin to Layer Colors*

Pastels, unlike paint, cannot truly be mixed. So you're going to layer one color on top of another to help the viewing eye think it's seeing mixed colors. Use an olive green hard pastel near the black pupil.

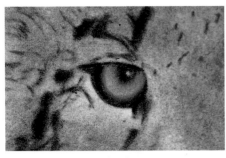

➤ STEP 5: *Add Reddish Brown*

Add just a halo of reddish brown close to the bottom lid of the eye with a hard, sharpened pastel. Part of what makes eyes so beautiful is the range of colors in each one.

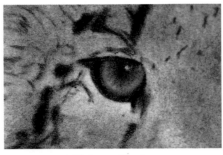

➤ STEP 6: *Add Some Darks*

Extend the dark area down from the black pupil with a brownish gray hard pastel.

DON'T OVERWORK

I am the "Queen of Overwork." In my opinion, more is always better. (My husband teases me about it all the time. If I fall in love with a pair of shoes I certainly need them in three colors…)

But not so on the eye. Get in and get out. It needs to be clean and clear, just like a real eye, and overworking only muddies up the detail and the color. Overworking other body parts can be fixed, but try not to do it on the eye.

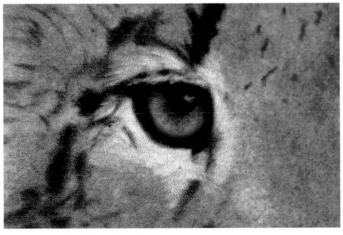

➤ STEP 7: *Redefine the Black, Again!*

You have probably lost some of the edges of your black in the process of adding color. It's time to reclaim them and make them as black as you think they need to be to balance the rest of the eye color. This and the white you're about to add give the eyes strength so attention is called to them. Eyes are there to be noticed.

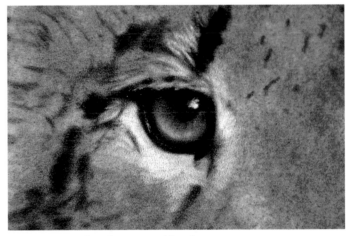

➤ STEP 8: *Go for the Pop! Add White*

This is what you've been working for—the white! Take a very sharp white hard pastel and very lightly put a bit of a white line along the bottom rim of the eye. This will give the impression that it is wet and alive.

Sharpen your pastel again and go back into that little space of gray paper you saved from step 2, and with the corner of your white pastel, put in your reflection. Now step back and be proud of yourself. You did a great job!

Cat Paw

Snow leopards are good subjects to use for practicing drawing paws. Their tails and paws are out of proportion to the rest of their body. The large paws help them walk in snow and their tails give them warm air to breathe when they curl it around their face. Their coats are spectacular, with large black spots, and have always been one of my favorites of all the big cats.

MATERIALS

Surface
Gray velour paper

Soft Pastels
Black
Brownish gold
Pale gray or light
 umber
Warm medium gray
White

Hard Pastels
Black

➤ **STEP 1:** *Apply the Basecoat*

Once you have your leopard pattern sketched in, use the side of a soft pastel (paper and label removed) to lay in a warm medium gray. I have a plastic box with dividers where I keep broken or short pieces of pastels. I take all labels off and use the sides of them to lay in larger blocks of color, usually for a base color on which to build detail later.

➤ **STEP 2:** *Begin Layering Color*

Choose a brownish gold soft pastel and, using the side of it, lay a bit of that color on top of your gray.

➤ **STEP 3:** *Don't Lose the Spots!*

Using a black soft pastel, darken the black spots of hair so you don't lose the lines that you have already sketched. Starting a sketch over at this point is not fun.

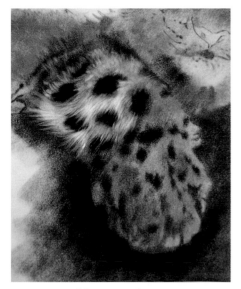

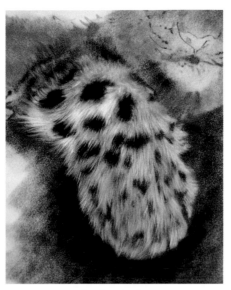

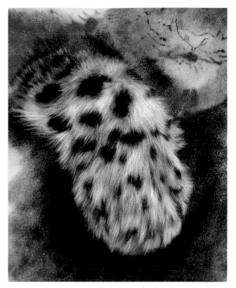

➤ STEP 4: *Add Some White Hairs*

Find your favorite white soft pastel and sharpen it. Put it in the areas where the hair will look the most white, stroking in the direction the hair grows. Don't use it everywhere or it will lose its effectiveness.

➤ STEP 5: *Apply the Undercoat*

Sharpen a pale gray or very light umber soft pastel like you would the hard pastels and lay in hair over the rest of the paw (avoid going directly over the spots), stroking in the direction the hair grows. If in doubt, find a research photo of a snow leopard (house cats have hair that grows in the same direction as their larger and more formidable cousins).

➤ STEP 6: *Redefine the Black*

Using a black soft pastel for the centers of the spots, go in and give them some punch. Make them really black.

Add some additional white hairs scattered across the paw.

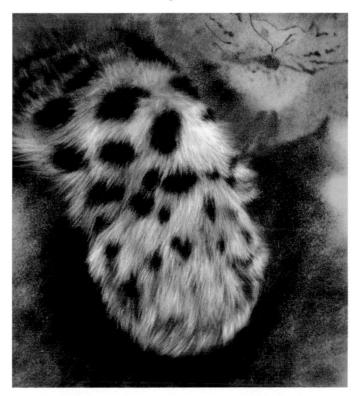

➤ STEP 7: *Final Touches*

Sharpen your white and pale gray soft pastels and drag a few of the hairs out of the black patches so they look more realistic.

It's always such a pleasure to see a painting by an artist that paints fur well. After all, for centuries, the fur of beautiful animals has been prized and sought after. This demo focuses on an area of the neck where some of the longer hairs grow and will show you how to do some of the white chin hairs, too.

MATERIALS

Surface
Gray velour paper

Soft Pastels
Black
Warm gold
Warm medium gray
White

Hard Pastels
Black
Light gray
White

► **STEP 1:** *Apply the Basecoat*

Just like you did on the paw demo, apply a base of warm medium gray using the side of a soft pastel. Then add some warm gold on top of that with the side of another soft pastel.

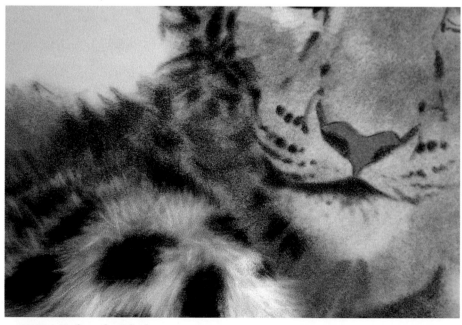

► **STEP 2:** *Define the Black*

Find your sketch marks for the black spots and reinstate them using a black soft pastel.

➤ **STEP 3:** *Add Wispy Hairs*

Sharpen a light gray hard pastel and wisp in hairs. They are longer and need to feel a little "freer," not short and stiff.

Sharpen your white hard pastel and add a few white hairs here and there. While you have your white all nice and sharpened, move over to the chin hairs; these are short and stiff. Paint them that way, with more pressure on the paper and shorter strokes.

➤ **STEP 4:** *Redefine the Black*

For a more powerful painting always go back in with your lightest light (here, use white soft pastel) and your darkest dark (here, use black soft pastel) as a finishing touch. It will help attract attention to the painting.

Now you know how to paint fur. Not hard at all, is it?

Canadian Lynx
➤ DEMONSTRATION

This young brother and sister lynx obviously have a lot of affection for each other and show it in this pose. It is rare to capture the lynx in a daily behavior as fun as this.

MATERIALS

Surface
Gray velour paper

Soft Pastels
Blue
Brown
Golden brown
Gold ochre
Gray
Reddish brown
Warm gray

Hard Pastels
Black
Grayish brown
Light tangerine
Rosy pink
White

➤ **STEP 1:** *Complete the Sketch*

Use a sharpened black hard pastel to sketch the lynx on a light gray piece of velour paper. Put all of the detail in now that you may need later. Velour paper cannot be erased on, so transfer the sketch from another piece of paper if you feel unsure about your sketch.

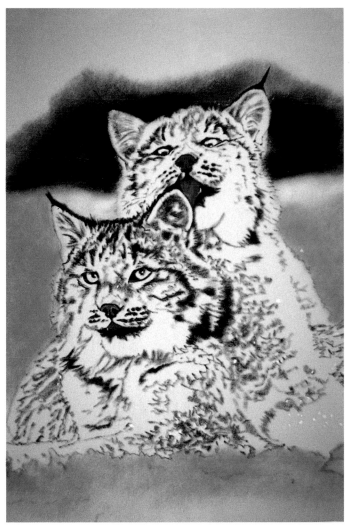

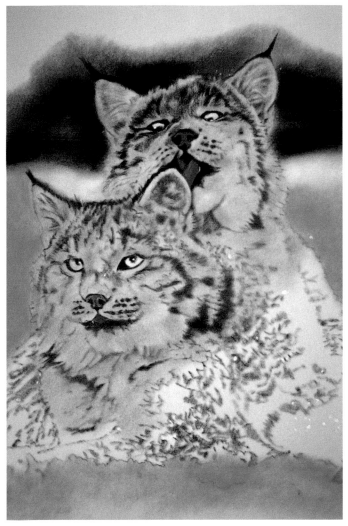

➤ **STEP 2:** *Lay Initial Colors*

Use the flat side of gray and brown soft pastels to lay in background color. Then, as a base for the snow that will go in later, lay down a pretty blue soft pastel as an undercoat for the white. Generally, I paint the whole background first so the animal will not look painted around, helping the hair look as if it is on top of the background, not the other way around.

Use a black hard pastel to define the darks so they stand out later when you need to find them. Use a rosy pink hard pastel as the base color for the nose and tongue. I like to see some color early on to cheer me up and make me feel I'm further along than I am!

➤ **STEP 3:** *Apply the Basecoat*

Use the broad side of a warm gray soft pastel to lay in a basecoat on both cats. The basecoat is important because everything you build from now on comes from this color.

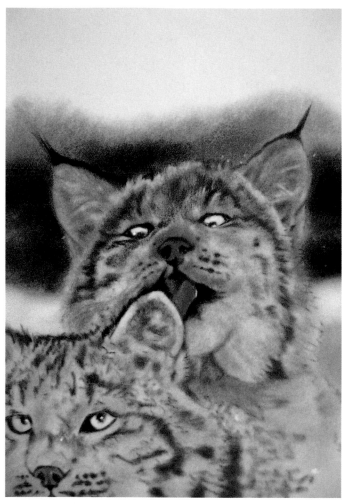

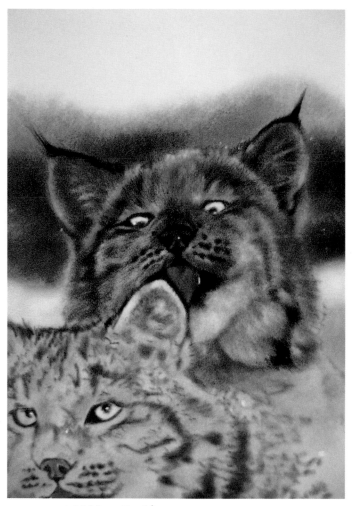

➤ STEP 4: *Add Color to Rear Lynx*

Use the broad side of a reddish brown soft pastel to lay in color over the whole face, leaving the eyes the color of the paper. When working with pastel the tooth of the paper holds only so many layers of pastel, so you don't want to use it up with unnecessary color.

➤ STEP 5: *Add More Darks*

With a grayish brown hard pastel, lay in more darks. This is done so the light hair of their coats will show up when you draw it in, and it will also help give the painting the depth to make it look more real.

For the nose, use a light tangerine hard pastel to add highlights. Continually go back in with your sharp black hard pastel to redefine lines after other colors soften them.

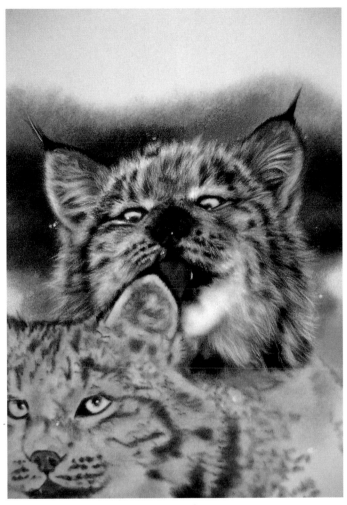

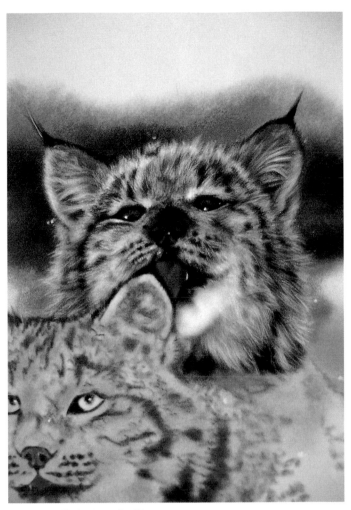

➤ **STEP 6:** *Begin Adding Hair*

Now the fun starts! Sharpen a white hard pastel and use one of the sharp edges to draw the hairs, one at a time. Make sure to stroke it in the direction the hair would grow. As the pastel gets dull, continue to sharpen it. Try working from left to right, or vice versa as needed, to keep from picking up some of the pastel on the side of your hand. Ideally, you'd like it to stay on the paper!

➤ **STEP 7:** *Painting the Eyes*

The painting looks alive after the eyes are in. Use a gold ochre soft pastel for a light-colored basecoat. Gently layer a richer golden brown soft pastel over the top of the basecoat.

Use a black hard pastel to define the blacks around the eyes. Use the corner of a sharpened white hard pastel to add a dot of a highlight in each eye.

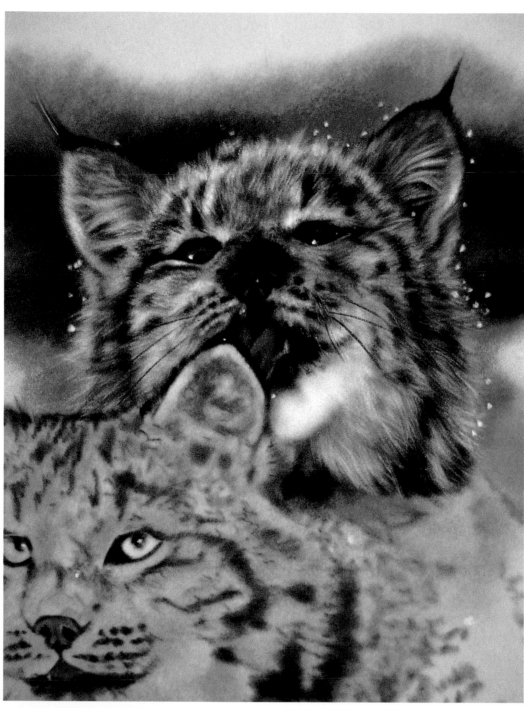

➤ **STEP 8:** *Add the Final Details*

To give the tongue some texture and contours, use a sharpened white hard pastel for lighter areas and a black hard pastel for the shadows.

Don't forget the whiskers and the tufts on the top of the ears. Sharpen your black hard pastel and stroke the whiskers out in the manner they would grow, using the sharp, fine edge.

As a finishing touch, sharpen your white hard pastel and add flecks of snow to his coat. It's easy to add too much, so take your time and stop before you go overboard. We want to see the cat, not just the snow.

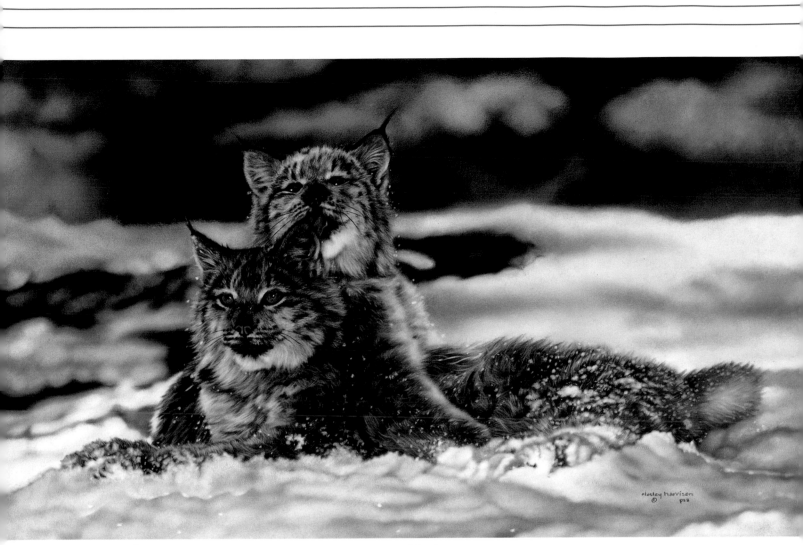

➤ STEP 9: *Finish Up*

Complete the other lynx using the same steps as done with the first lynx.

For the background, add blues and lavenders around the cats, then add white soft pastel on top of that to look like snow. Add bright sparkles to the snow with hard pressure from the soft white pastel.

Add some reddish browns and blacks vaguely into the far background to pick up and repeat the color from the cats.

Friends
Pastel on velour paper
14" × 24" (36cm × 61cm)
Private collection

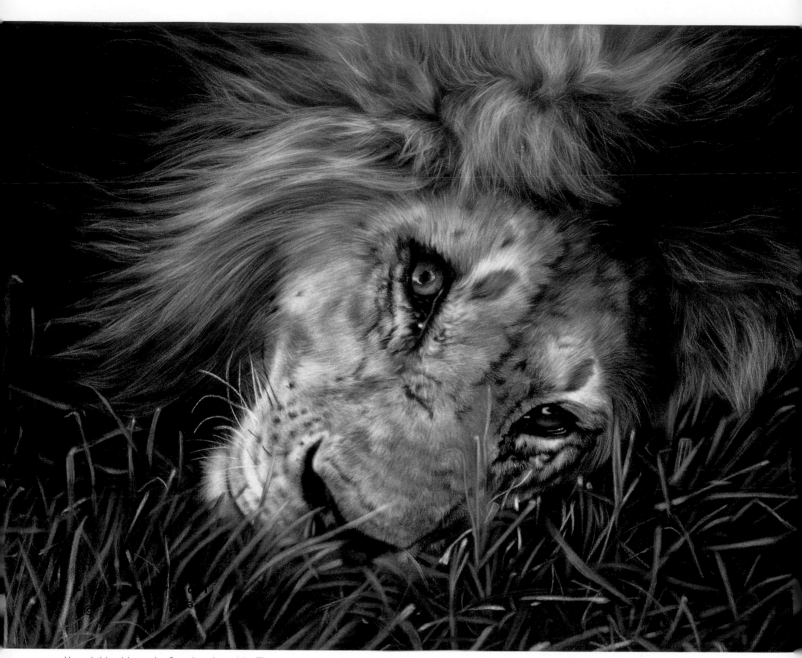

I loved this old guy the first time I saw him. The expression in his eyes, the scars on his face and his weary body language spoke to me with so much emotion I just had to paint him. I didn't paint all of his scars, as too many would be distracting to the viewer and would take attention away from his eyes.

Many Moons
Pastel on velour paper
12" × 15" (30cm × 38cm)
Private collection

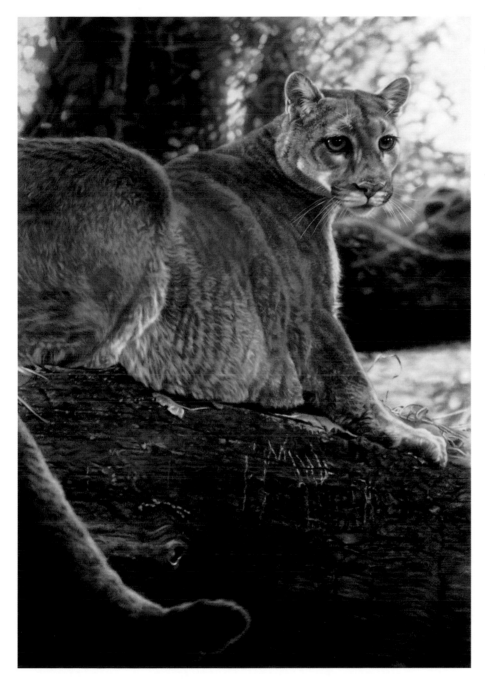

I know this cat and love this painting because of it. She is so regal looking and is one of the prettiest mountain lions I've painted. She belonged to my friends and was my first introduction to a "privately owned" cat. To take the reference photos for this painting we put her in the back of the station wagon and drove her out to an open area; she purred the whole time.

The look you see on her face is the result of one of her "people" playing with her by pulling her tail. She was a bit peeved.

Woodland Royalty
Pastel on velour paper
24" × 18" (61cm × 46cm)
Private collection

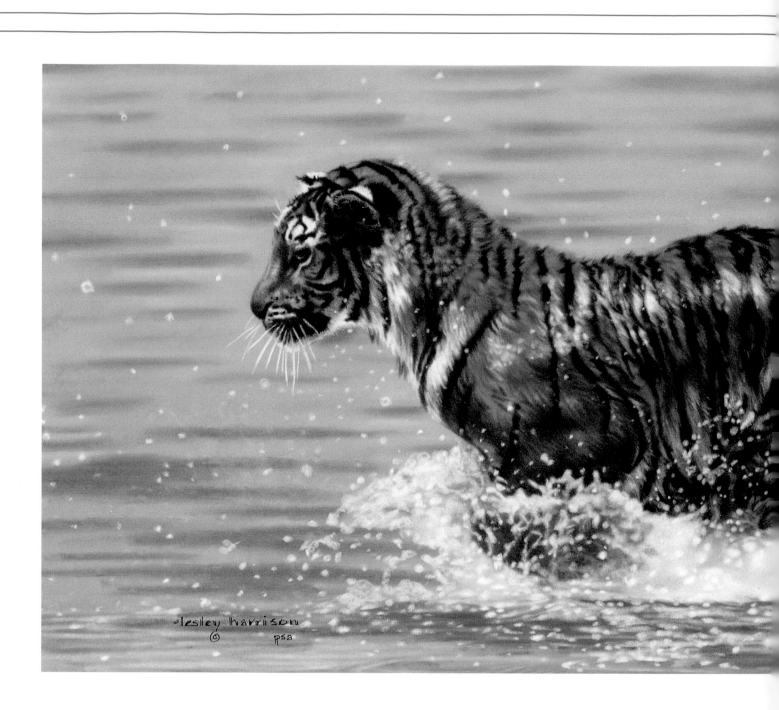

This painting came from two days of photos at Marineworld (an ocean wildlife park in Vallejo, California), sweating in the 100-degree heat and shooting through a chain-link fence and over the heads of other people. Because it is tough to get reference material like this, we don't see too many paintings of big cats in high action. This guy was actually chasing a toy in the pool the handlers were using to keep the tigers moving. There's a feeling of power and poetry unleashed when a tiger moves into action.

Tiger Running
Pastel on velour paper
10" × 26" (25cm × 66cm)
Private collection

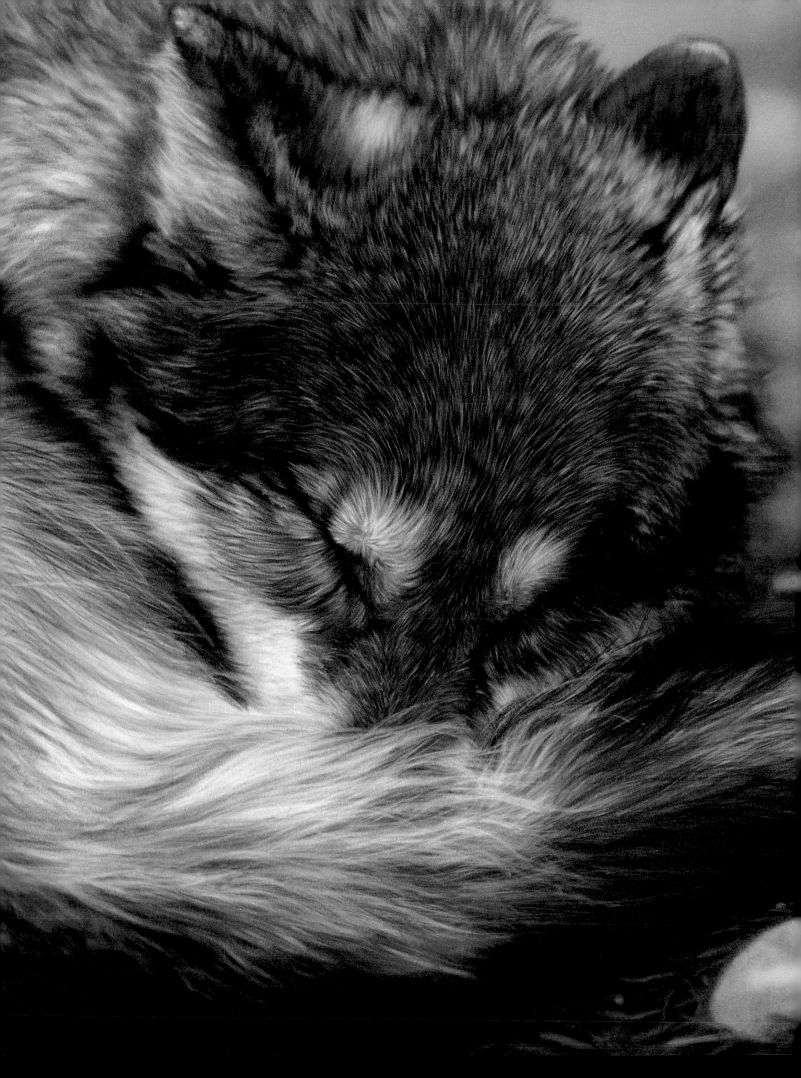

Wolves

I'll never forget the first wolf I was able to touch. I had been painting them for a couple of years but had only seen them through chain-link fencing and photographed them with long lenses. When I got to sit down in the snow next to a huge male wolf and touch him, I was in awe! He was enormous, awe inspiring and a bit intimidating. But his coat—wow! Gorgeous. The artist in me was fascinated by what I was finally seeing up close. And to get to sink my hand in that beautiful fur—words escape me.

Wolves are not easy to paint by any stretch, and are very different from the dogs that we all know so well. The hair patterns on a wolf go every-which-way. And their faces and eyes are unlike any other. Another challenge is to make a wolf look friendly. You know the "Big Bad Wolf" concept. I think most of us have bought into it, whether we know it or not.

This chapter will help you to accurately portray wolves. I've developed not only an admiration for their beauty, but an emotional response to who they are.

A Quiet Moment
Pastel on velour paper
16" × 12" (41cm × 30cm)
Private collection

49

You don't need me to tell you that wolves have gotten a lot of bad press. They do kill to eat and feed their families, and as the world continues to shrink this becomes more and more of a problem for the people and animals that share the wolves' environment.

Needless to say, it is probably not wise to paint wolves in an aggressive posture or stance. Their aggressiveness is an awesome thing to behold and beautiful in its own way, but something most of us would rather not witness.

Wolves have their own rules and have lived by them for thousands of years. Much of their growling, snarling, lip curling and aggressive behavior is a part of the system they live by. It's all part of the language they speak and understand among themselves.

The fact of the matter is, wolves do not look friendly, no matter what they do! Their eyes are penetrating and they have a way of looking at you that makes you think it might be a good time to move to another planet. Painting their interaction

with each other in friendly ways can take the focus off of how intimidating they tend to look.

The photographic reference material on this page shows wolves in very aggressive postures. Wolves can give you the heebie-jeebies no matter how far away you are!

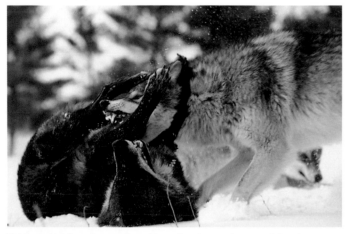

Wolves do a lot of posturing with each other and most of the time no one gets hurt. As artists we don't do wolves any favors or please our viewers by painting them in this manner.

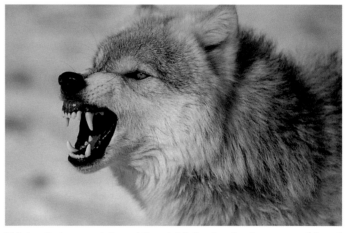

This is called an agonistic curl. It certainly inspires fear in everyone's heart!

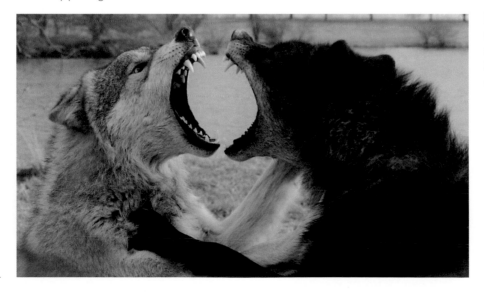

I'm fascinated by this photograph. I think most of us are a bit in awe of predators, and wolves are certainly right up there are at the top. Needless to say this is not something we would want to paint to make people feel good.

Loyal, Sensitive Pack Member

Wolves are known for having an amazing social system. The more we learn about them the more fascinating it becomes. They take care of their own; all members of the pack help care for the new pups and teach them to hunt. Animals in a pack will fight and sometimes kill outsiders, including lone wolves that may present a threat to the safety of the pack. Wolves hunt together to bring down large game and carry meat for miles for those too old or too young to hunt.

As with any animals, the babies are delightful to paint. They do such funny, naive things as they are growing into the awesome predators that they will become. Their games, naps and interaction with each other can give an artist a lot of ideas to work with.

I was taken with this wolf, Sage. He seemed so old and so wise. He didn't expend a lot of energy and it seemed to me as if he was thinking back on his life as it drew to a close. I hoped that by painting him this way others would feel the same emotion I did.

The Old Wolf Remembers...
Pastel on velour paper
12" × 17" (30cm × 43cm)
Private collection

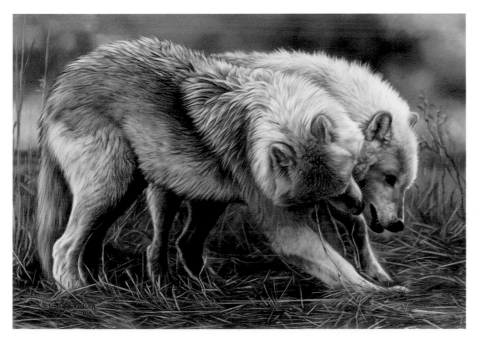

These two wolves were litter mates and belonged to friends. I sat with them for three days. They stayed a safe distance away from me, but by the third day they were comfortable enough with my presence to play and cavort with each other in their huge pen. It made me happy to see how much fun they had with each other.

Time for Play
Pastel on velour paper
16" × 22" (41cm × 56cm)
Private collection

Wolf Ear

Wolves have a wonderful soft, fuzzy area on the backs of their ears (just like a dog) that is different from any other fur on their body. This ear is taken from *A Tender Moment*, the painting of two wolves tangled up with each other that appears on page 64.

To keep your paintings interesting, look for body positions that are different from what we traditionally see—animals sitting, lying down or walking. How about leaping, running or twisting? Grab the viewer with something fresh and different.

MATERIALS

Surface
Gray velour paper

Soft Pastels
Light brown
Medium gray

Hard Pastels
Black
Dark gray
Light gray
White

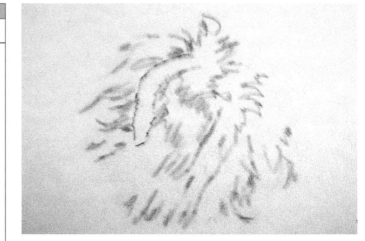

▶ STEP 1: *Sketch the Ear*

Take a sharpened black hard pastel and sketch in the ear and surrounding fur on gray velour paper. The gray paper is neutral and will not tone the finished white wolf in any way.

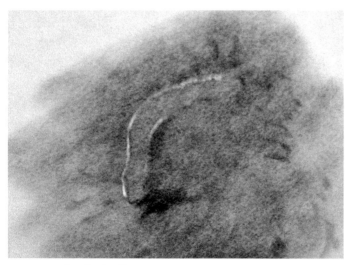

▶ STEP 2: *Apply the Basecoat*

Use a medium gray soft pastel as a basecoat. Use the side of it to add a layer of pastel over the whole ear area.

Make sure you can still see your drawing lines underneath, and remember that the paper can only hold so much pastel. Don't use up all the nap with your first color.

Use your white hard pastel to define where the top hairs on the ear will be so you can put color on the ear without losing your drawing.

▶ STEP 3: *Add Light Brown*

Do exactly the same thing you did with gray in step 2, but with a light brown soft pastel. With pastels, you cannot mix colors in the traditional sense, so you must lay one color on top of another until the eye thinks it's seeing mixed colors.

➤ **STEP 4:** *Add Some Darks*

Use a dark gray hard pastel to start laying in your darks. This is the part where I start having fun because I know the darks are what allow the detail I'm going to put in next to show up.

➤ **STEP 5:** *Add More Darks*

To give the ear more depth again, use your black hard pastel and go over the dark gray you just added. Your ability to balance the strong contrast gives the painting eye-catching appeal. The darks play against the lights and the warm tones play against the cool tones.

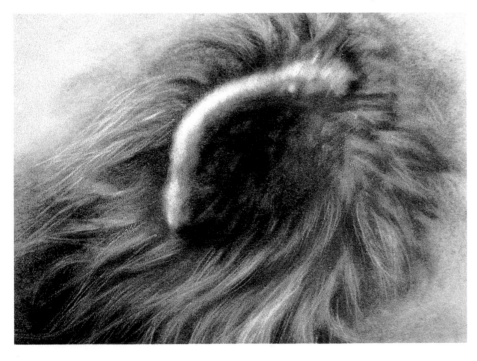

➤ **STEP 6:** *Add the Lights*

Here's when the painting comes alive for the viewer. Use a sharp light gray hard pastel to lightly stroke in the individual hairs. Remember, these are very soft, fine hairs. Put a few short delicate strokes on the back of the ear and longer hairs around it. Then go in with a very sharp white hard pastel and start adding your final details.

White and black used judiciously work well. They need to be used to make the work "pop," not overload it.

Doesn't this ear look so soft and fuzzy that you want to touch it? Since most people will probably never get this close to a wolf, your artwork can become the next best thing. One of the privileges of being a wildlife artist is to help others experience animals in a way that they otherwise never would.

Wolf Paw
► DEMONSTRATION

Wolves have amazing paws. In the wild they can travel up to twenty-five or thirty miles a day in deep snow looking for a meal. They have tremendous endurance—it's hard to imagine an animal that can spend all day in the snow and not get cold feet.

MATERIALS

Surface
 Gray velour paper

Soft Pastels
 Medium gray
 Reddish brown
 Warm dark gray

Hard Pastels
 Black
 White

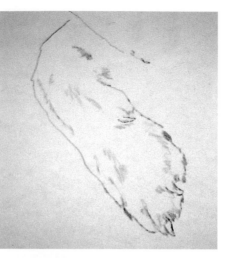

► STEP 1: *Sketch the Paw*

Use a sharpened black hard pastel to draw in the paw you want to practice on. I'm using a paw from the same two wolves on page 64.

► STEP 2: *Apply the Basecoat*

Take a medium gray soft pastel and use its side to apply a coat of color over your drawing. Try not to bury your original sketch lines because you're going to need them.

► STEP 3: *Add Detail and Color*

With your black hard pastel, redraw your lines and add more definition to the toenails. After you've done that, go back with a reddish brown soft pastel and lay down the color.

► STEP 4: *Add Dark Gray*

Take the side of a warm dark gray soft pastel and fill in the paw. You'll learn as you do this exactly how dark or light you want it. Basically, what you want is for the color it to be dark enough to show off and "pop" the colors you add later. You may wish to err on the side of being too light, as it's easier to make colors darker than it is to try and lighten them.

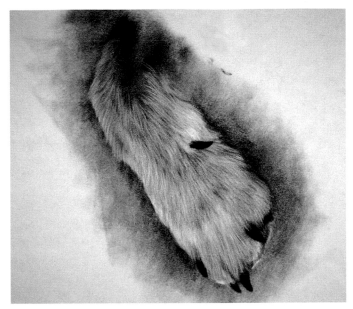

► STEP 5: *Start Adding Details*

Use a sharp white hard pastel to start adding the hairs on the paw. Think about the paw on your dog or cat. The hairs there are much shorter than they are anyplace else on the body, except the face. Make them short and going in the correct direction.

Fine-tune the toenails with the black hard pastel, making the nails a little darker. Work back and forth from dark to light as you see things changing until you're finished.

► STEP 6: *Add Highlights*

Sharpen a white hard pastel and lighten up some areas of the fur so they stand out over the other areas. Even fur has highlights, depending on how the light is hitting it. Using that same white, carefully highlight the toenails.

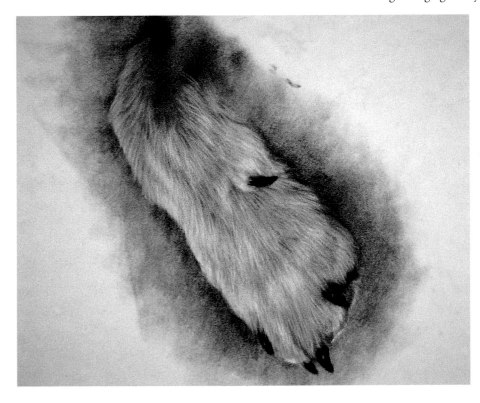

In my experience, painting animals with long hair is much easier than painting animals with shorter, sleeker coats. The shorter, sleeker coats show everything—muscles, tendons, ligaments and veins. When I painted my first wolf I was surprised to find that they are very labor intensive because of their beautiful coats. True, the coats cover a lot, but they are not easy if you want to do them correctly. And since they're so beautiful, of course we want to do them right!

MATERIALS

Surface
Blue velour paper

Soft Pastels
Medium gray
Golden brown

Hard Pastels
Black
Off-white
White

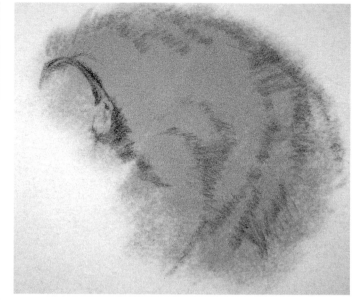

➤ **STEP 1:** *Apply the Basecoat*

We are using the wolf from *Snow Flurries* (page 9) for a model because he has such a gorgeous coat. I've chosen a blue piece of velour out of consideration for the background snow. In the area between his ear and shoulder blade, use the side of a medium gray soft pastel to lay down color for a basecoat.

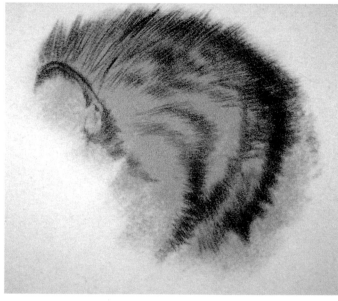

➤ **STEP 2:** *Add the Darks*

Use a sharpened black hard pastel to add the dark hairs on the wolf's ruff (the area of long hairs around the neck). Work loosely with the black and don't pile all the color in one spot. These are hairs which need to be layered to look dark black in the darker areas.

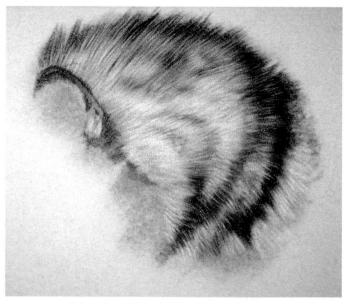

➤ **STEP 3:** *Add Light-Colored Hair*

Sharpen an off-white hard pastel and start adding lighter hairs in and around the dark ones.

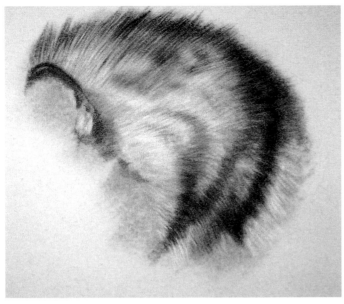

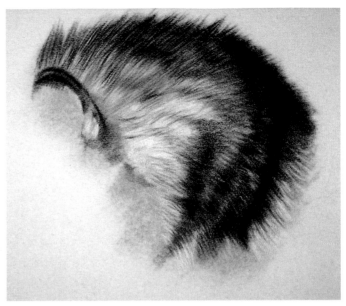

➤ STEP 4: *Add Warmth*

Add a suggestion of color with a golden brown soft pastel to warm up the painting and make the wolf more visually inviting.

➤ STEP 5: *Use Some Serious Black*

For our final touches we want to tune up the black again, so sharpen your black and decide where you want concentrations of black and where you want the fur to be lighter. The beauty of fur is how free and wild it can be. Don't overwork fur or it will lose its spontaneous feeling.

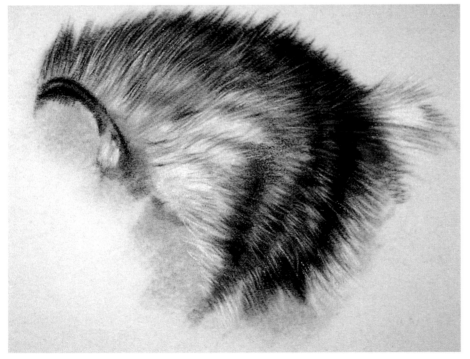

➤ STEP 6: *Add White*

With a sharpened hard white pastel lift some of the lighter hairs over and around the black to make them look finished and more realistic.

In my reference photography this wolf is lying on a frozen lake with a huge plastic ball. No one knew exactly what would happen when he was given the ball.

I liked the look on the wolf's face, the fact that he was doing something different, the play of colors against each other (the wolf's warm colors against the blue and white of the frozen ice) and mostly the reflection of the orange ball in the blue ice.

The primary consideration in painting from this photograph is that the painting needs to be believable. To do this, we'll change the ball into a pumpkin, something more true to nature. We also want to portray a wolf that isn't intimidating, so we need colors to work together in a pleasing way.

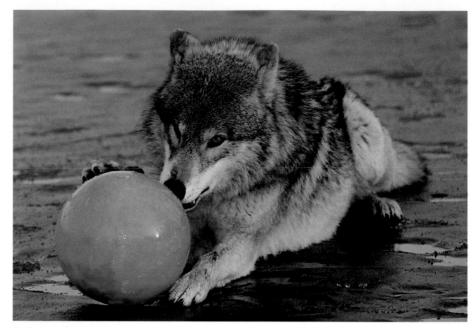

Reference Photo

MATERIALS

Surface
Gray velour paper

Soft Pastels
Black
Brown
Dark blue
Dark brownish
 purple
Golden brown
Medium-light gray

Hard Pastels
Black
Dark brownish gray
Dark gray
Lemon yellow
Light gray
Pink
Red
White
Yellow gold

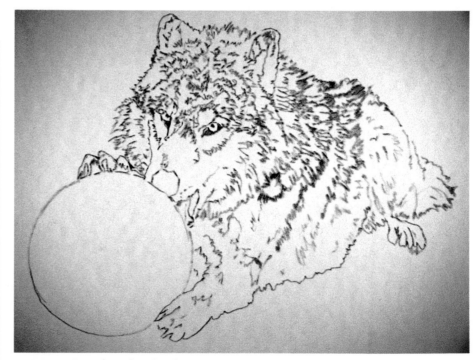

➤ **STEP 1:** *Complete the Sketch*

Sketch in the outline of your wolf with a sharpened black hard pastel, drawing in the approximate area where you think the pumpkin will be positioned later. Gather reference photographs of a pumpkin, grass and ice. It's dangerous to start a painting without having visuals for each and every part.

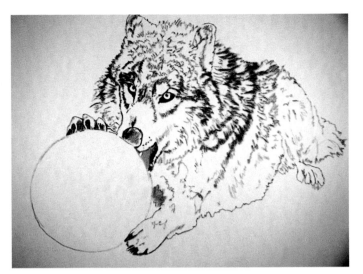

➤ **STEP 2:** *Plan Ahead*

Draw in the blacks so you can find them later. Add some pink hard pastel for his tongue. There is really no artistic reason to put the pink in now except it's fun to have a little color to cheer you up during the beginning stages.

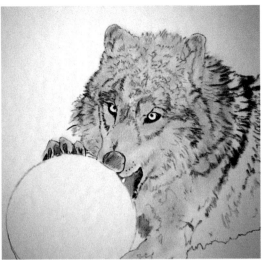

➤ **STEP 3:** *Add the Basecoat*

Use a medium-light gray soft pastel over all of the wolf. Don't let the basecoat touch the eyes because they are so delicate to work on.

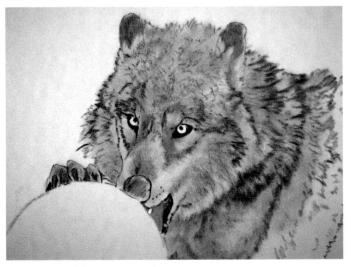

➤ **STEP 4:** *Add Brown*

Using the side of a brown soft pastel put a layer of color on top of the gray. Using the side of the pastel will cover the desired area more evenly. Don't use a super-soft pastel at this point. It will use up all of the tooth in your paper and you won't have room to add more pastel as you need it. Save the super-soft pastels for contrast, punch and dramatic effect at the end. At this point in your painting you're trying to rub off color onto the paper as opposed to adding a lot of pastel.

For additional color, add golden brown soft pastel on top of the brown you just added.

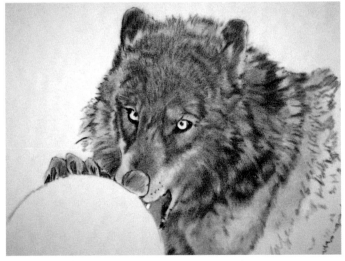

➤ **STEP 5:** *Add Dark Hair*

Using an unsharpened dark brownish gray hard pastel, go over all the darkest places on the wolf's fur to lay the groundwork for the details that will come later.

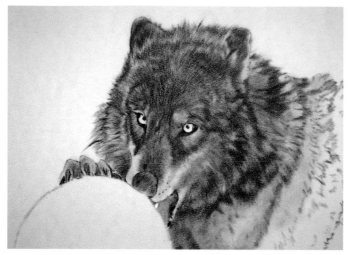

➤ **STEP 6:** *Work on the Undercoat*

Use a dark gray hard pastel to build up the dark areas. This part becomes rather arduous but is worthwhile. So don't despair!

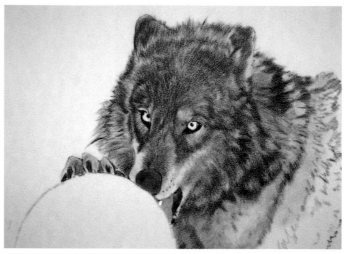

➤ **STEP 7:** *Add Vibrant Color*

I always enjoy adding a dark blue soft pastel undercoat when working on animals. The viewer will never see it later, but it tends to make the darks much richer. An undercoat of blue is usually appropriate any-place you might use black later. Some artists never use black; I like to use it sparingly on top of other colors that are already very dark. The danger in using a black pastel without any other dark colors under-neath it is that it tends to appear flat and lack vibrancy.

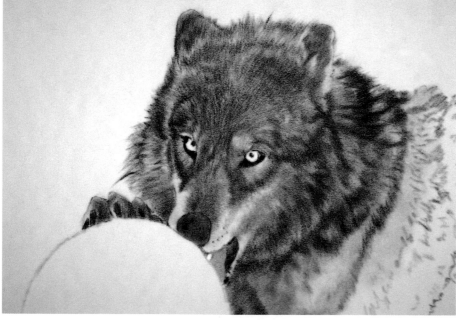

➤ **STEP 8:** *Continue Building the Undercoat*

Use a dark brownish purple soft pastel to go over the darkest spots again.

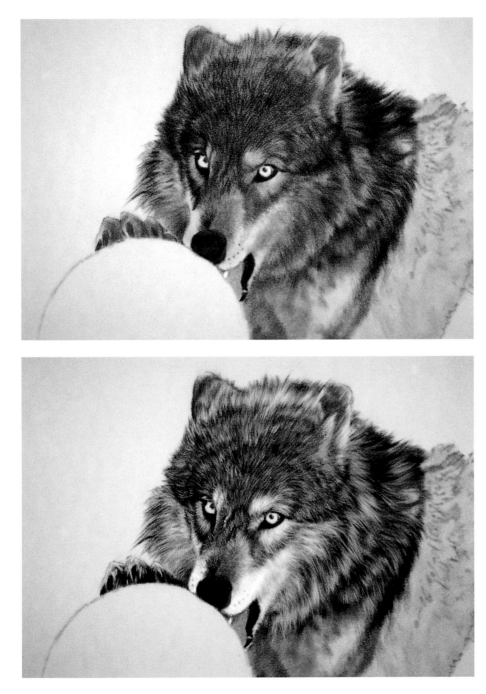

➤ **STEP 9:** *Add the Final Darks*

Use an unsharpened hard black to go over all the darks that you have been slowly adding. It may look like you're covering up all of your hard work, but it will help you achieve the depth and richness of a realistic wolf coat.

➤ **STEP 10:** *Begin Adding the Details*

Sharpen a light gray hard pastel and stroke in each hair in the direction that it would grow.

Sharpen a white hard pastel and sparingly stroke in hairs on top of the light gray to make the hairs stand out.

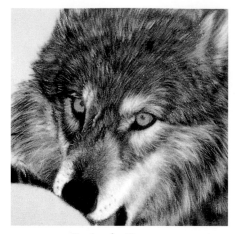

➤ **STEP 11:** *Begin the Eyes*

Painting eyes terrifies and excites me because so much depends on them. If the rest of the painting is absolutely perfect and the eyes don't quite make the mark, it will never have the same impact. Wolves have very distinctive eyes. Adults generally have amber eyes but they also can range in the gray-greens. To start working on this wolf's eyes, use a yellow gold hard pastel.

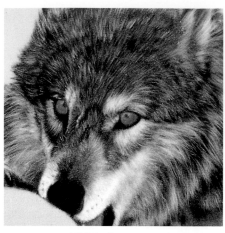

➤ **STEP 12:** *Add Red*

Use a red hard pastel and add color to the outside part of the eye. Be careful not to overwork this part of your painting.

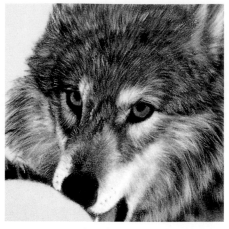

➤ **STEP 13:** *Define the Pupil and Add Color*

Take your sharp black hard pastel and add pupils by stroking soft lines outward from the center.

Use a sharp lemon yellow hard pastel to add a bit of yellow at the bottom of each eye. Then go over the pupil and black areas with a softer black pastel to add a richer, darker black.

➤ **STEP 14:** *Add Highlights*

Use a sharpened white hard pastel to put a dot of light right in the pupil. Also add a bit of white outside of the pupil to give it more life and dimension.

With a sharp red hard pastel, add a little color underneath the eyes. Dab a touch of white on top of that. Add a dot of white up in the corner of the left eye and see what a difference it makes. The rims of the eyes look wet!

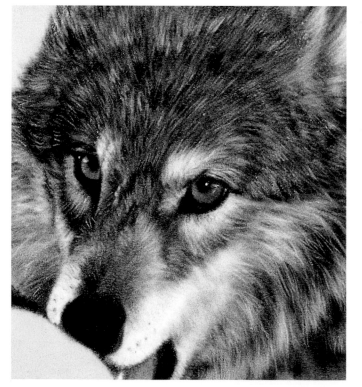

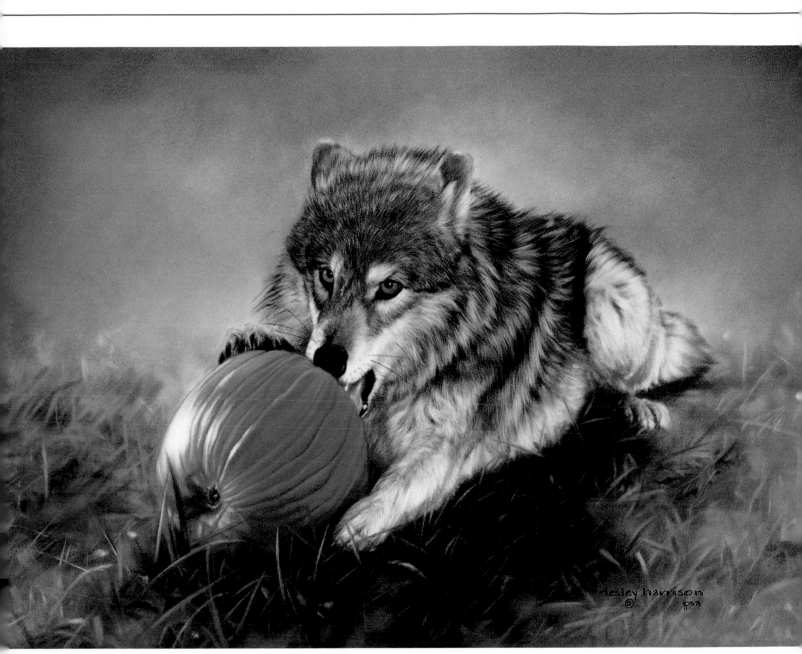

➤ **STEP 15:** *Add the Final Touches*

Add a little bit of light gray to the nose so it won't appear flat and uninteresting. Then add pink in the shadowed areas of the tongue, with a little bit of black on top of that and white for your highlights.

Don't forget the whiskers. I've done it before! Sharpen your black hard pastel as sharp as you can get it and carefully lay in the whiskers. Put them in the same way they would grow, starting with the muzzle and moving outward. That way they will be thicker at the muzzle and get thinner as you get ready to lift your pastel off of the paper.

Congratulations, you have just completed one of the most difficult animals to paint.

Treat
Pastel on velour paper
11" × 13" (28cm × 33cm)
Private collection

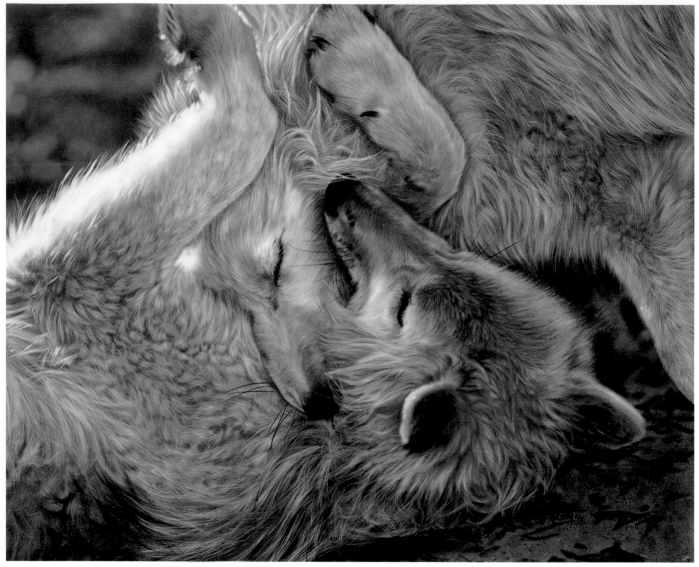

This was a painting that I absolutely loved creating. Sometimes a painting almost paints itself. It seems to flow effortlessly without any direction from the artist. I don't know about other artists, but it only happens to me once every few years. Because so many paintings are fraught with problems to solve, the ones that flow are especially appreciated and remembered.

This one took a long time to complete because of the wolves' fur. The way they were entwined with each other felt so sweet to me and I loved creating it. A dear friend now owns it so I can visit it once in a while.

A Tender Moment
Pastel on velour paper
16" × 20" (41cm × 51cm)
Private collection

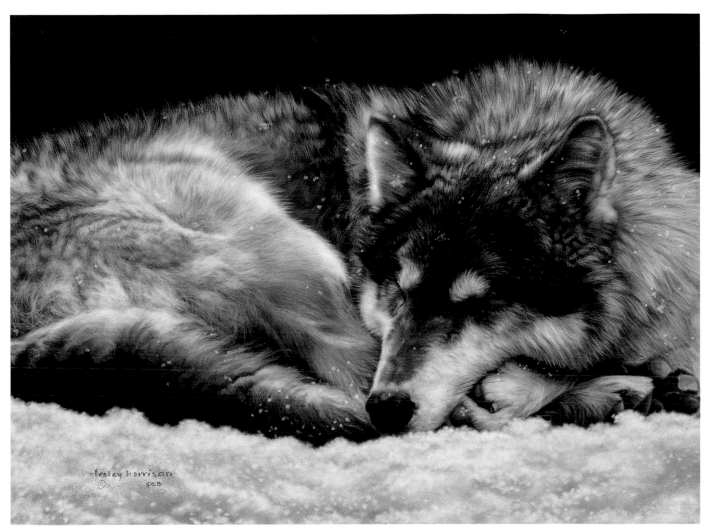

My original plan for this painting was to almost completely cover the wolf in fresh snow. Wolves, because of their magnificent undercoat, can sleep in temperatures up to 30 degrees below zero. Isn't that amazing? It's another tidbit learned from reading every wolf book I can find.

But after working on that phenomenal coat I didn't have the heart to cover it up with snow. So here we have a wolf sleeping in the snow with a few snowflakes here and there to show off that beautiful fur.

And the Wolf Dreams...
Pastel on velour paper
15" × 20" (38cm × 51cm)
Private collection

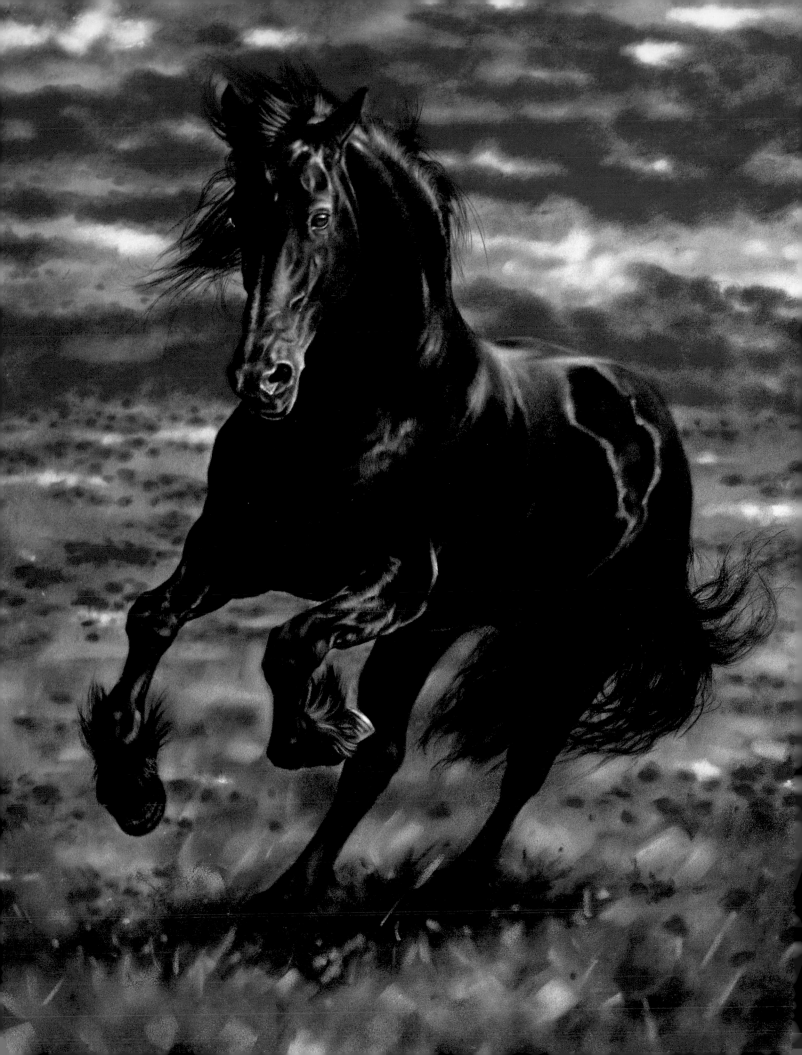

Horses

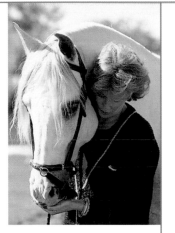

As recently as two days ago, visiting clients brought friends to see our studios and showroom. They were laughing and telling their friends about how they never have had any special fondness for horses, yet they have bought three of my horse paintings. In all the years that I have been painting horses I have heard this story over and over again. It makes me smile for many reasons, especially because over the years galleries and publishing companies have told me over and over that they couldn't sell horses.

In this chapter we'll zero in on some of the things about drawing and painting horses that make them so intimidating to paint. If we break a horse down in parts and work on those parts, the whole horse should be much easier to tackle. Working on the eye, a leg and the mane individually should help build your confidence in painting these gorgeous animals.

Bold and Beautiful
Pastel on velour paper
22" × 16" (56cm × 41cm)
Private collection

67

Wild and Powerful

As with any book, movie or painting, most of us want to see or read things that make us feel good or have a happy ending. I painted these two wild Mustang stallions and I actually got to witness this scene. I knew that the horses wouldn't hurt each other badly because the stallion on the right was older and had already established his dominance. However, none of the viewers knew that this scene had a happy ending. In their minds the ending could have been mutilation or death. So, unless you're only painting for yourself and planning to hang all the paintings in your own house, it helps to try to look at them through a stranger's eyes.

Against the Wall
Pastel on velour paper
16" × 20" (41cm × 51cm)
Private collection

Gentle Giants

The wonderful thing about painting the things you love is that you usually surround yourself with those things, either consciously or unconsciously. And if you surround yourself with the things you love, you should never run out of ideas!

I've never had any negative reactions to this painting! It's fun to watch people's delighted response when they see it. It's not about having to stretch and paint things you don't know; it's simply about painting what makes you smile and knowing it will affect others in the same way.

This painting was inspired by the antics of funny little cats when they're around huge horses. The cats are clueless that a horse could destroy them in a split second. One day at home when my husband and I were brushing our horses one of our cats, Duffy, was hanging in one of the horses' tails by his claws! We thought for sure he was going to die! But the horse just kept swishing his tail with Duffy swinging back and forth until we quietly walked over and removed him. Since I love cats and horses, it's always great fun to try to figure out a way to paint them together. Actually, they'll figure it out for you if you watch them long enough!

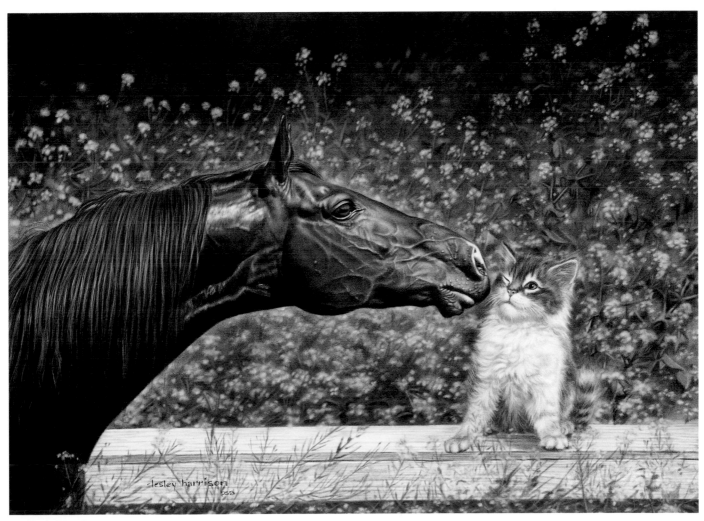

Dubious Friends
Pastel on velour paper
18" × 24" (46cm × 61cm)
Private collection

Horse Eye

All living creatures show so much emotion in their eyes and horses are no different. You can tell if a horse is worried, scared, calm or excited just by looking in his eyes.

As you spend time around horses, you'll eventually be able to translate their different looks and what they mean.

Horses have glorious, large, lustrous eyes, and that's how you want them to look in your painting. Sometimes it means you may want to enhance what they naturally have to make them look better than they are. But first you have to become familiar with the way a pretty eye looks and how to paint it. Let's get started!

MATERIALS

Paper
Blue velour paper

Soft Pastels
Light reddish
 brown
Reddish brown

Hard Pastels
Black
Light blue
White

► STEP 1: *Sketch Your Guidelines*

I used blue velour paper because I put a blue sky behind this horse when I did the background. Use any color you want and sketch in the details of the eye, paying special attention to the shape.

I usually put a dot of reflection in with a sharp white hard pastel so I don't lose where it goes later and because I like the feel of a "live" eye when I start painting.

► STEP 2: *Apply a Basecoat*

Lay down a reddish brown soft pastel basecoat over the entire eye area. Be sparing with your pastel on the eye. Pastels are really hard to correct if you are too heavy handed and make a mistake. If you lay down a lot of thick color, it's difficult to go back and redo if you have a problem. If anything in the painting needs to be close to perfect, it's the eye. The eye sets the tone for the whole painting, especially if you're painting a head portrait where the eye is a focal point and people can see it clearly.

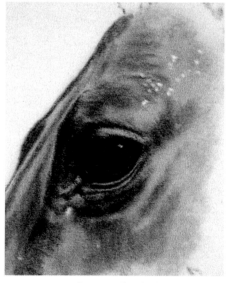

► STEP 3: *Define With Black*

Using a sharpened black hard pastel, add black creases and details around the eye to show the socket, corners and lid detail. Use black to show the pupil in the middle of the eye. This horse was in sunlight when I photographed her, so the pupil is just a slit. When there is less light, it becomes larger. Use white to add a small sunlit highlight to the eye.

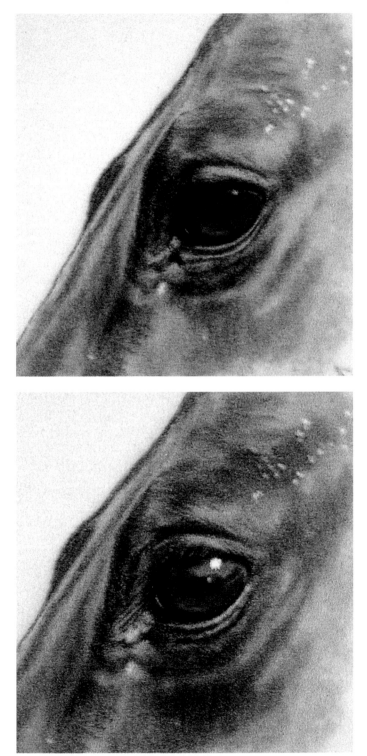

➤ STEP 4: *Add the Highlights*

This is where the fun begins because the highlights on an eye show depth and life. I love watching little dabs of color add so much.

Use a light reddish brown soft pastel and gently apply it in the bottom oval of the eye, following the line of the eye. At the same time, take a sharpened light blue hard pastel and dab a little color in the right corner of the eye. This separates the iris and the white membrane. If you can see the whites of a horse's eye, it usually means he is worried or scared about something and you want to get out of his way!

➤ STEP 5: *Add the Final Touches*

Now the last and final touches. Using a very sharp white hard pastel, highlight the areas around the eye so the lids and corner of the eye stand out. Then use a light coat of white hard pastel to show the general reflection and a strong dot of white to show the main reflection. This eye has two reflections because there must have been two light sources from something behind me. One is enough, but if you like the way two look, add them both.

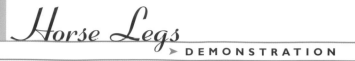
I think that ballerinas and horses have the most exquisite legs in the world. Because of that, I love painting them and you will too when you see how simple they are. The secret is in making sure your initial sketch is accurate.

If you want to challenge yourself, try pushing the limits by accentuating reality, fluffing it up a little to make it a little more wonderful. For example, if you're painting the leg of a horse and you know horse anatomy well, you can take that beautiful curve or line and accentuate it a little more. You're simply taking something that is really nice and making it even nicer.

MATERIALS

Paper
 Light blue velour
 paper

Soft Pastels
 Brownish red
 Dark blue

Hard Pastels
 Black
 Dark gray
 Medium gray
 White

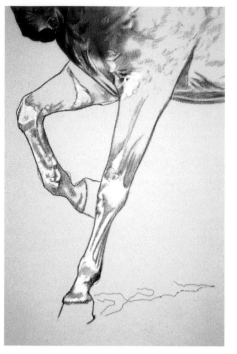

➤ **STEP 1:** *Sketch in the Leg*

Using a sharpened black hard pastel, sketch in the outline of the leg. Lay in some white hard pastel where the tendons, muscles and curves around the knee are. I used light blue paper because I planned to put gray clouds behind him with some of the blue sky showing through.

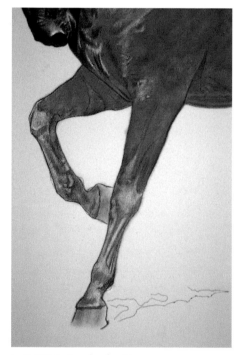

➤ **STEP 2:** *Apply the Basecoat*

Since you aren't painting a blue horse, you need to create a new basecoat. The horse is a bay, which means he has a brownish red body with black legs, mane and tail.

For this basecoat use a brownish red soft pastel and cover the whole leg.

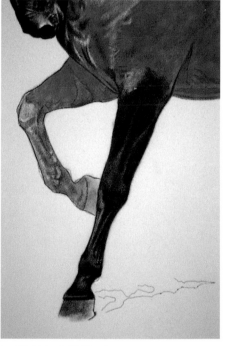

➤ **STEP 3:** *Add Darks*

To build up colorful darks, use a dark blue soft pastel to lay in the "black" areas. You've heard the term "blue-black"? That's what you're creating.

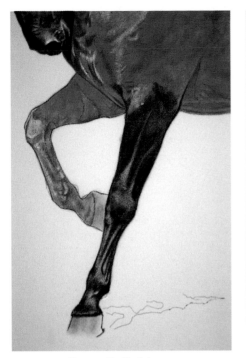

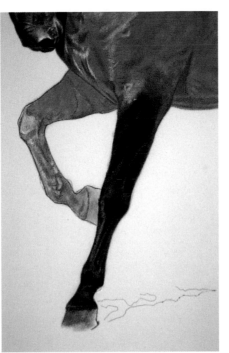

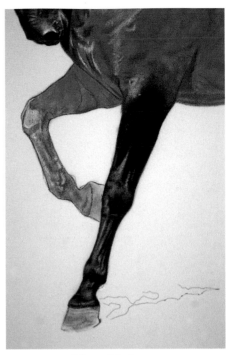

➤ **STEP 4:** *Create Definition*

Build luster beneath the black with a dark gray hard pastel. The top part of the leg, or forearm, has some beautiful muscles that you want to define. From the knee down, you will want to define bones, tendons and ligaments and try to make them look real. Don't get discouraged! I've heard a lot of artists say that a horse's legs are the most difficult part of the anatomy to paint.

➤ **STEP 5:** *Now for the Black*

Now that we have prepared the undercoating, give the leg some punch by covering it with black.

➤ **STEP 6:** *Add Highlights*

Go back over some of the muscles, tendons and ligaments with a medium gray hard pastel, using your white hard pastel for the brightest highlights.

When painting a horse, remember that each horse is an individual. Study the differences that make the horse you are painting who he is—color, shape of the ears, color of eyes, hair whorls and which direction they go.

Work to get the color correct. I have found over the years that the rich color that some horses have takes a lot of work to try to put on paper. But it's so pretty when you get it right!

Pay close attention to the structure of a horse's face. The skin is stretched so thinly over the beautiful angles and curves of the bone structure. There are some good anatomy books available that can help you until it becomes second nature.

The horse in this demo is not only a gorgeous color (it's the same horse from pages 72-73), but he's also fun to paint because he has so much energy and natural flash.

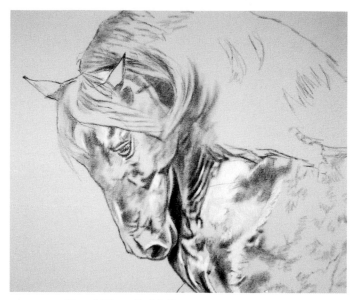

➤ **STEP 1:** *Sketch Your Guidelines*

Sketch your initial outline with a sharp black hard pastel. Then lay in some of your detail and add some highlights with a white hard pastel for placement. It will make it much easier later so you don't lose those angles!

MATERIALS

Paper
Blue velour paper

Soft Pastels
Dark reddish
brown
Light reddish
brown

Hard Pastels
Black
Dark gray
Off-white
White

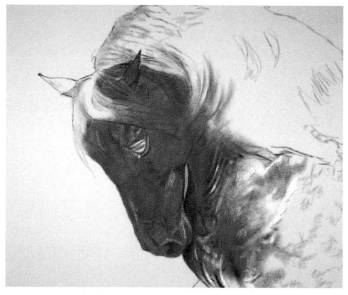

➤ **STEP 2:** *Apply the Basecoat*

I used blue velour paper because of the background I planned. But, for this color horse, beige paper would be better. With the blue paper you'll have to lay in a beige basecoat by rubbing a light reddish brown soft pastel over the whole area to be painted, except for the eye.

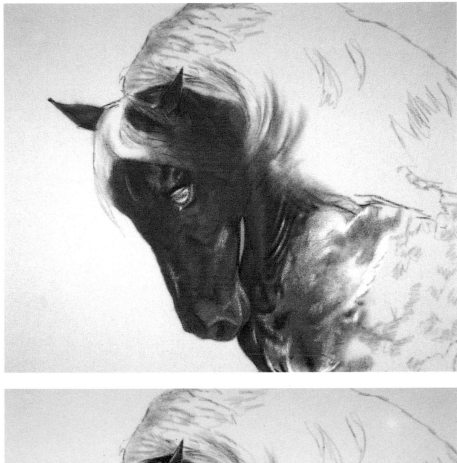

➤ **STEP 3:** *Add More Color*

Use a dark reddish brown soft pastel to layer
on top of your base color. You are working
on giving this horse a rich coat color.

➤ **STEP 4:** *Create Contours and Shape*

Use a dark gray hard pastel to start defining
some of the horse's bones, veins and muscles.
By shadowing them you'll make them stand
out. But remember, use gentle strokes.

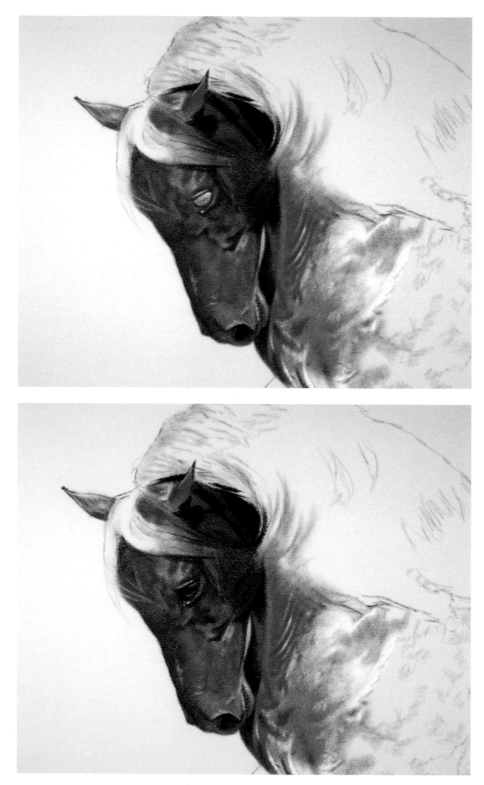

➤ **STEP 5:** *Add Some Black*

Add some black inside his nostril, behind his ear and under his chin to make the deeper shadows stronger.

➤ **STEP 6:** *Add the Eye*

Eyes on dark horses are generally darker than on light-colored horses. Some palominos and buckskins have very light amber-colored eyes, whereas horses with white markings around the eye can actually have blue eyes. This horse has beautiful dark eyes; use dark reddish brown as a base. Horse eyes are much like ours in that they have a top and bottom lid and eyelashes, so don't forget those. (For a full eye demonstration see pages 70-71.)

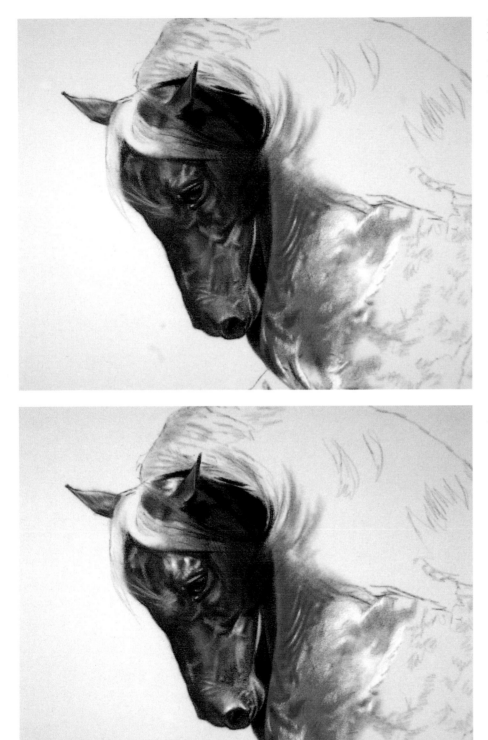

➤ STEP 7: *Lighten It Up*

Use an off-white hard pastel to start adding the lighter areas on the horse's face. These will be the highest areas that the light catches the most.

➤ STEP 8: *Final Touches*

To make the horse come alive, use a sharpened white hard pastel and add some glisten above the eye, on some of the bones and above the nostril. Isn't he gorgeous?

Hair truly is a "crowning glory" for all of us, human or animal. A beautiful horse with a puny mane and tail is not quite as exciting as one that has thick, long gorgeous hair. Because it is so important to the overall look of the painting, let's spend some time learning to paint luxurious hair.

MATERIALS

Paper
 Blue velour paper

Soft Pastels
 Black
 Dark gray
 Deep blue

Hard Pastels
 Black
 White

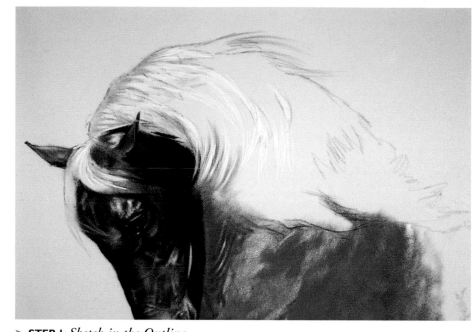

> **STEP 1:** *Sketch in the Outline*

I used a blue piece of paper because I have planned to have a blue and gray sky behind this horse when finished. Since the mane is going to be black, you can choose any color paper that you would like because the black pastel will cover anything.

After you have chosen your paper, draw in some light lines to show where you want the mane to go. Put in some of the highlights now so you can find them later.

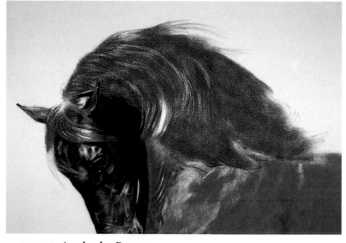

> **STEP 2:** *Apply the Basecoat*

Lay in the basecoat of this black mane with a deep blue soft pastel.

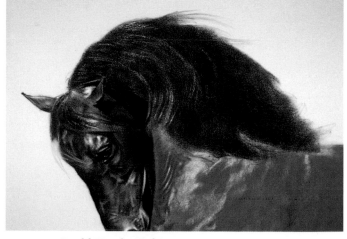

> **STEP 3:** *Build Up the Color*

To add depth and volume to what is to become a lot of hair, start darkening it by putting a layer of dark gray soft pastel over the blue.

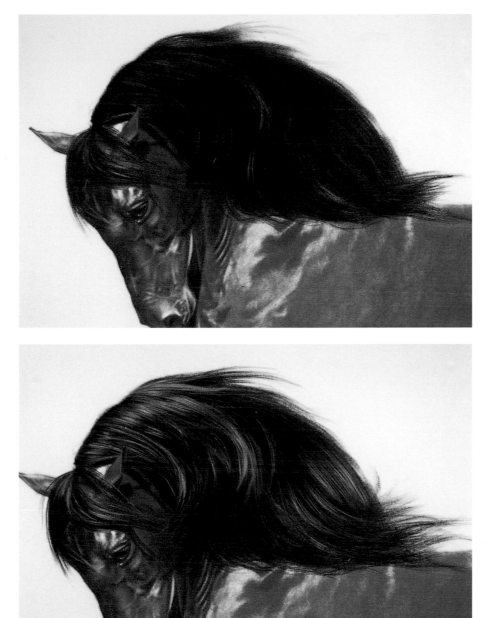

➤ **STEP 4:** *Add Black*

Use a deep black soft pastel (all blacks are not equal), stroking the color in the direction the mane would be flowing. The individual strokes may not show with black, but I still always lay color on in the direction of the hair.

➤ **STEP 5:** *Add the Sheen*

The highlights on anything are what make it come alive and give it the finishing touch. Using a sharpened white hard pastel, add highlights where the light would be hitting the mane as if the horse is cavorting out in the sun or strong light source.

This wasn't as intimidating as you thought, was it? A lot of artists are afraid to do hair or fur. It just takes time, patience and the know-how.

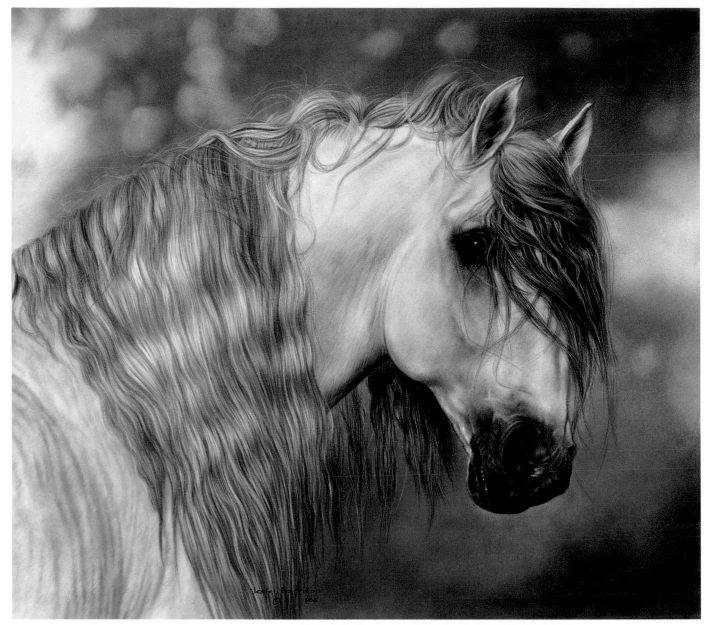

I really fell in love with this Andalusian stallion, only to find out that he had been totally blind since age two. He had a tremendous amount of presence and dignity; hopefully you can feel it from the painting.

Excalibur
Pastel on velour paper
15" × 17" (38cm × 43cm)
Private collection

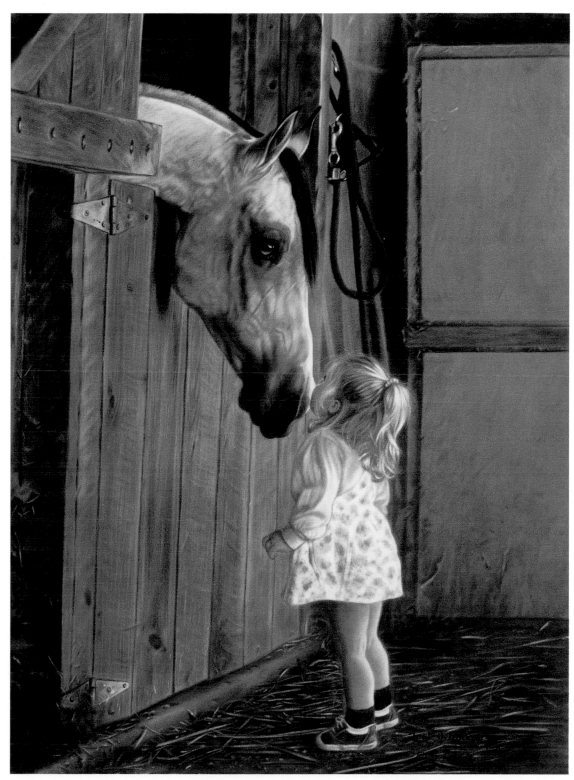

There are many precious moments shared between children and horses when they think nobody is watching. This is one of them.

Little Visitor
Pastel on velour paper
20" × 16" (51cm × 41cm)
Private collection

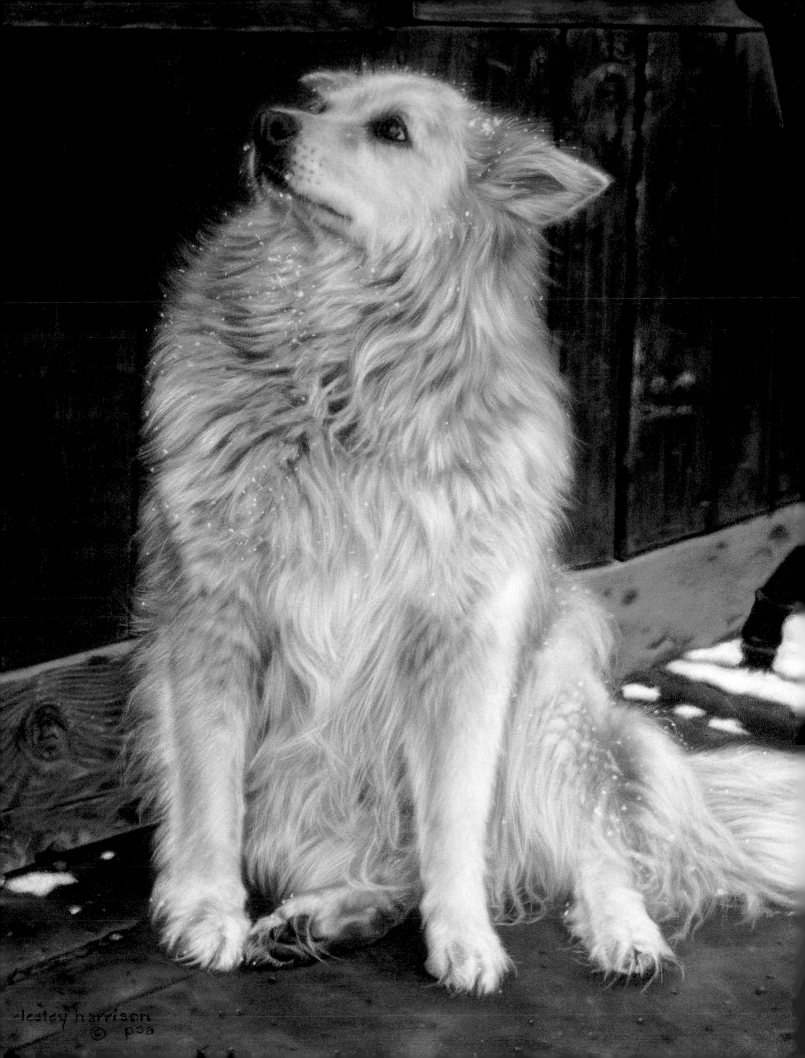

Dogs and Cats

CHAPTER FIVE ➤➤

There are very few households that don't have at least one dog or cat. We grow up learning about animal love, loyalty and companionship from the family dog or cat. There would be so much lacking in our lives without their unquestioning love and devotion, emotions that we often wish we could receive from the humans in our lives. Their loyalty is unconditional and can be an oasis when we need relief from the pressures of everyday life.

Because we are around them all the time, dogs and cats are natural for us to paint and it is great fun to learn to portray them in different ways and poses. Most of us have a perfect model sleeping on the couch right now or waiting for us to take them for a walk.

No Dogs Allowed
Pastel on velour paper
20" × 16" (51cm × 41cm)
Private collection

BRAINSTORM PAINTING IDEAS

If you want to have some fun, sit around over a cup of something hot in a coffee shop (preferably out of town, someplace fun) when it's pouring down rain and brainstorm painting ideas with a friend. My husband and I did that one day and came up with a bunch of fun sketches on napkins to try when we got home. We didn't know how cooperative the kitties themselves would be, but we sure had some great new ideas for how to use cats in a painting.

I called our local humane society and spoke to the director about "borrowing" some kittens. They were kind enough to let me do that and the fun began!

It Can Be Harder Than It Looks!

The first thing we did to create this painting was drive all over our area (we live out in the country) looking for a mailbox with some "character" to it. After we found that, and asked the owner's permission to use it, we went to get our borrowed cats. It sounded so easy—put cats on door of mailbox, photograph them and paint them. Right!

We had three people, three cats and a mess! One kitten dove for the back of the mailbox and hid back there. The other two cats bailed and headed for the hills. After we rounded all of them up, we put collars and neon orange string on each one (it could be painted out) and stuffed the mailbox with some grocery bags so the cats couldn't get in there to hide. This is the finished painting. You'd never guess, would you? Looks so peaceful and idyllic.

Rural Route 2
Pastel on velour paper
18" × 14" (46cm × 36cm)
Private collection

KEEP YOUR EYES OPEN

Be super-aware of what you're looking at all the time, no matter how mundane it seems—the way the light falls on an object, the positioning of an animal, or the possibilities of a background for something else you already have in mind to paint.

Keep That Camera Handy!

Is there anything cuter than an eight-week-old puppy? We were in Fort Worth, Texas for a horse show and wandered down to Old Fort Worth one day. I spotted these puppies a block away and zeroed in on them. The owner was very nice and let us pet the puppies. He and his wife had just bought them to replace a very dear older dog that had died. I had a little point-and-shoot camera with me and asked if he would mind if I took some pictures. When we got home I changed the puppies around a bit, but loved the shirt and his hands. The title became a play on words because of the shirt.

A Special Brand of Love
Pastel on velour paper
8" × 12" (20cm × 30cm)
Private collection

The face of a cat is one of the most diffi-
cult and delicate things to paint correctly.
Adding the finishing touches of the short
hairs around the nose and the whiskers can
be especially trying with something as large
as a pastel stick. I've tried lots of techniques
over the years and this is how I do it today.

MATERIALS

Surface
 Beige velour paper

Soft Pastels
 Dark gray
 Medium gray

Hard Pastels
 Black
 Dark brownish gray
 Peach
 White

> **STEP 1:** *Establish the Sketch*

Use a black hard pastel to loosely sketch the cat face. When the sketch is in place, go over your
lines to darken. Add white whiskers in one stroke with the side of a sharpened white hard pas-
tel. Using one stroke is important because even the steadiest hand can't go back in and pick up
a whisker and make it look like one continued line when it isn't.

> **STEP 2:** *Apply a Medium Value*

Use the side of a medium gray soft pastel as the base for the cat's face.
Using the side of the pastel will give you broad, even strokes.

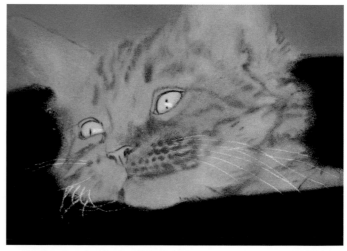

> **STEP 3:** *Establish the Whisker Base*

Choose a dark brownish gray hard pastel to lay in the hairs at the base
of the whisker. Stroke them in softly, remembering that these are
short, soft hairs.

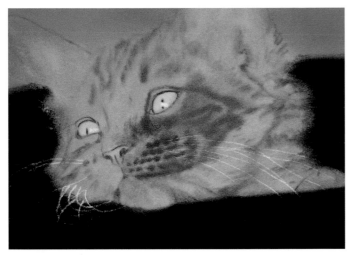

> **STEP 4:** *Deepen the Value*

Use a dark gray soft pastel over the browns to deepen the whisker base and give the fur depth.

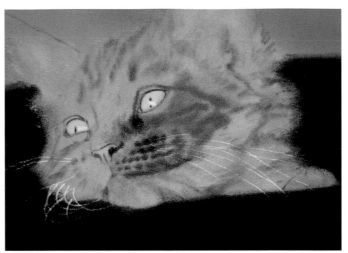

> **STEP 5:** *Add the Almighty Black*

Now for some power and oomph, get out your black hard pastel and make the hairs at the whisker base a little darker, still applying the color softly and gently; they are only hairs, just darker.

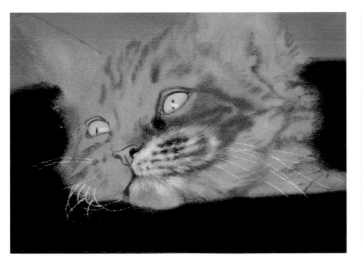

> **STEP 6:** *Add Some Highlights*

Add some peach hard pastel near the lip area. Then start adding white, short hairs, stroking them in the direction they grow. Examine the different ways that these hairs change direction. This is my favorite part of a painting. White makes a dull painting come alive! It's so exciting after working for days or weeks to see it come together with white highlights.

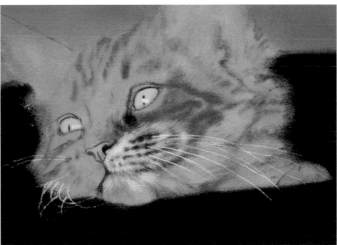

> **STEP 7:** *Bring Back the Whiskers*

Sharpen your white hard pastel and very lightly go over where you added the initial whiskers. All you're doing is clearing off the pastel dust that is sitting on top of what you already did.

I've chosen a wonderful dog named Sophie as the model for this eye, because hers are so beautiful. Maybe it's partly because her fur is gray, which always sets everything off so well. Whatever it is, her eyes are exquisite and we can practice using her as a subject.

MATERIALS

Surface
Tawny beige velour
paper

Hard Pastels
Black
Brownish violet
Gold ochre
Reddish brown
White

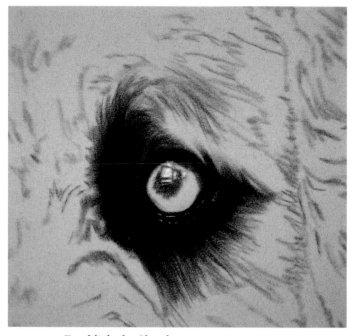

➤ **STEP 1:** *Establish the Sketch*

Using a sharpened black hard pastel, loosely sketch in the eye. Use a white hard pastel to establish the highlight area within the pupil and around the rim of the eye. Then, using a black hard pastel, start finding your detail and darkening the blackest parts around the eye. This is just an extension of the more loosely done sketch.

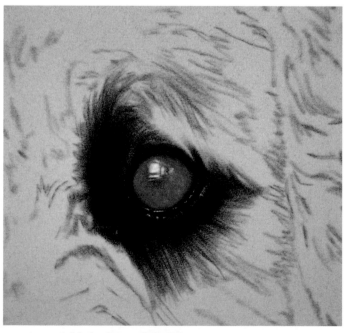

➤ **STEP 2:** *Add the Base of the Iris*

Fill in the base color for Sophie's eye with a reddish brown hard pastel. Use a hard pastel instead of a soft pastel because the eye is so small.

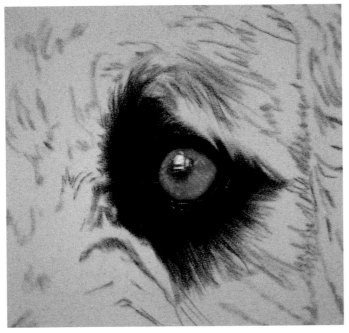

> **STEP 3:** *Develop Local Color*

Using a gold ochre hard pastel, gently stroke some color on top of the base you've already applied in the iris. Some of the reddish brown should still show through. Stroke away from the pupil toward the outside of the eye.

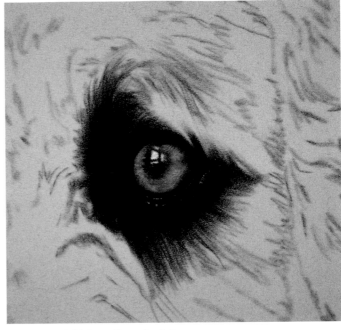

> **STEP 4:** *Add Detail to the Iris*

Start adding detail and depth to the iris with a brownish violet hard pastel. Add just a little bit within the iris and around its outer edges, then add a bit of black on top of that. The key to good eyes is not to overwork them; most of the time, less is more. You can always go back later and add more color, but taking it out is almost impossible.

> **STEP 5:** *Strengthen the Highlights*

Eyes are wonderful and reflect whatever light source is near them. I photographed Sophie in a screened-in porch, so the windows are reflected in her eye—hence the strange shape to the white, but pretty when looked at overall. Use your white hard pastel to re-establish the highlights in the iris and around the bottom rim of the eye.

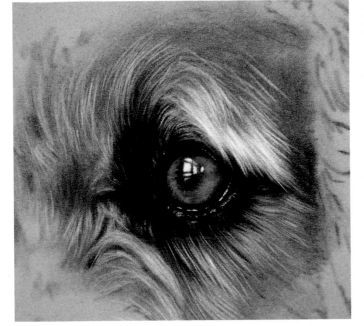

One of the fun things about painting cats is the variety in eye color they have. This eye is modeled from a beautiful and sweet Siamese mix that we found as a stray kitten. This is from one of his baby photos.

MATERIALS

Surface
Blue velour paper

Hard Pastels
Black
Light blue
Medium blue
White

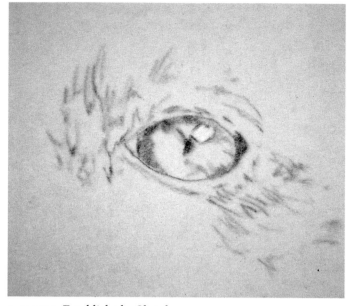

> **STEP 1:** *Establish the Sketch*

With a black hard pastel sketch in the outline of the eye. Notice that the pupil is triangular in a cat, not round (unless it's very dark) or square. This cat was outside when I photographed him so his pupil has receded all the way. Add the highlight at this point with a white hard pastel.

I chose blue velour paper as it best matches the color of the eye, allowing for a little less pastel in the long run.

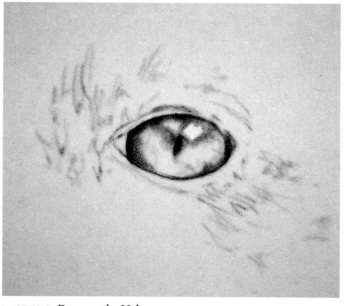

> **STEP 2:** *Deepen the Values*

Using the same black hard pastel that you used to sketch, go back in and start placing the details in and around the eye.

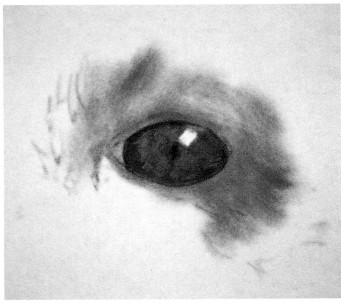

> **STEP 3:** *Apply the Basecoat*

Use a medium blue hard pastel and apply it in the iris for your basecoat. Don't cover the white highlight. Use a sharpened light blue hard pastel to add a few light squiggles on top of the darker blue that you just applied.

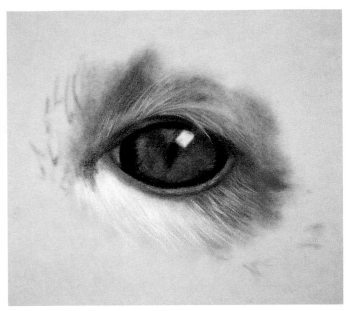

> **STEP 4:** *Add Black*

Sharpen your black hard pastel and make your darks blacker around the eye, shading the eye and the pupil.

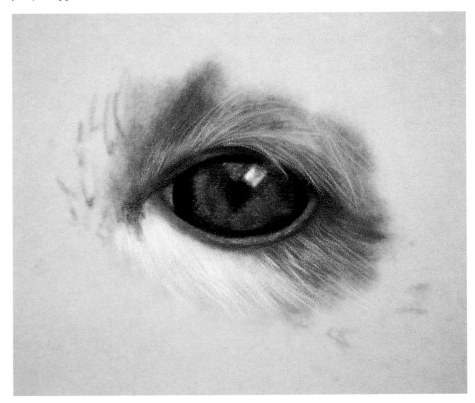

> **STEP 5:** *Tone Down the Highlight*

Since we put the highlight in first and it looks a bit bright, use a light blue pastel to tone down the top edges. Then add a little white next to it and some on top of your light blues. Stand back and see what you think.

Moments like this (see photo at right) are unusual and precious. I saw this photo on a Christmas card, and fell in love with it! It was not staged. This dog, Wally, and the cat, Bundy, really love each other and do these things on their own. Their owner, Margie, was kind enough to give me permission to paint from her photograph. To avoid any misunderstandings, make sure to ask the photographer or pet owner to sign a release that shows you have permission to use the photo as reference.

Reference Photo

MATERIALS

Surface
 Beige velour paper

Soft Pastels
 Black
 Dark gray
 Deep golden red
 Golden brown
 Medium gray
 Reddish brown
 White

Hard Pastels
 Black
 Brownish gray
 Light blue
 Light cream
 Pale gray
 Pale yellow-green
 White
 Pink
 Pinkish red

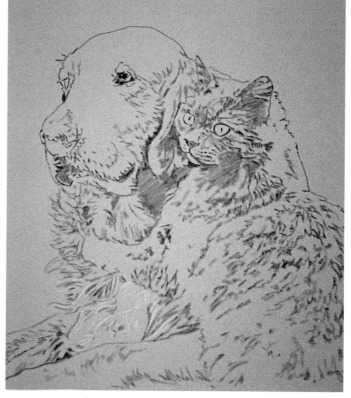

> **STEP 1:** *Establish the Sketch*

Planning and doing sketches beforehand on other paper and then transferring a final sketch to your velour surface is essential for a good painting, especially on velour paper where erasing and reworking is difficult. Lightly sketch in the outline of the dog and cat with your black hard pastel.

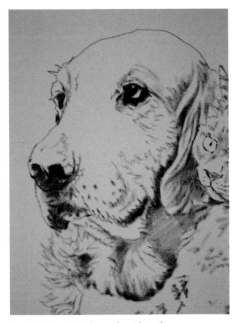

STEP 2: *Darken the Sketch*

Your faint sketch showed placement and detail; now add more detail with a black hard pastel. It's easy to do at this stage and it warms you up for the job ahead. Start adding darker areas to get a sense of the balance of the painting.

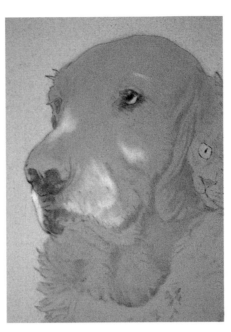

STEP 3: *Lay in Medium Tones*

Use the side of a medium gray soft pastel to cover the whole area of the dog except the eyes. Then put a golden brown soft pastel on top of that. Don't use too much pastel at this stage; you don't want to lose the detail lines or use up all the paper. Use a white soft pastel for the whites on his face, for placement only at this stage.

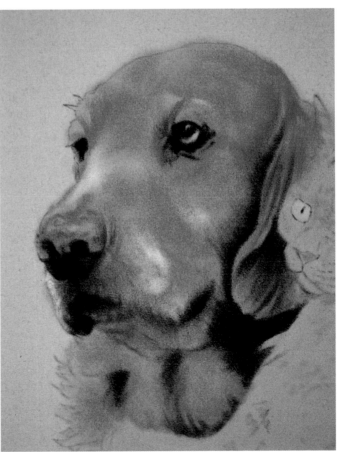

STEP 4: *Tone the Darker Areas*

Use a reddish brown soft pastel to start toning the fur on Wally's face and neck. With a dark gray soft pastel and then a black hard pastel, start putting in the grays and blacks on and around his nose, ears, mouth and eyes. He's starting to look like a very sweet dog, which is what you want. When painting other people's animals, it's important that they look like the animal, not how you think they should look.

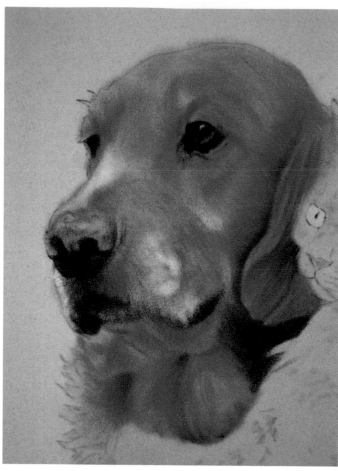

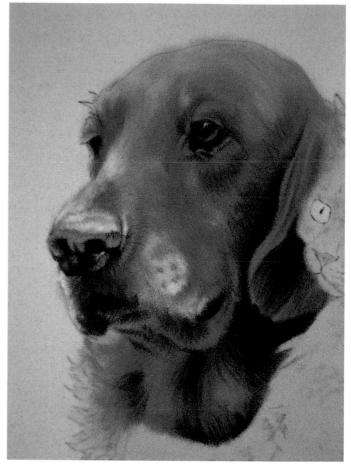

▶ **STEP 5:** *Develop Local Color*

Find a deep golden red soft pastel and go over the darker areas of his fur yet again. This should be the perfect color for his sweet eye, too, so color in the iris of his eye while you have this color out.

▶ **STEP 6:** *Add Detail and Further Develop the Color*

Find a delicate pink hard pastel to use on his nose. You don't want the nose to stand out, just to look realistic.

Now use a brownish gray hard pastel to start defining the planes and contours of his face more. This will be your last step before adding lights to make the painting come alive.

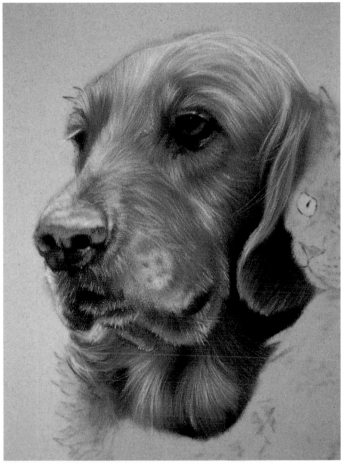

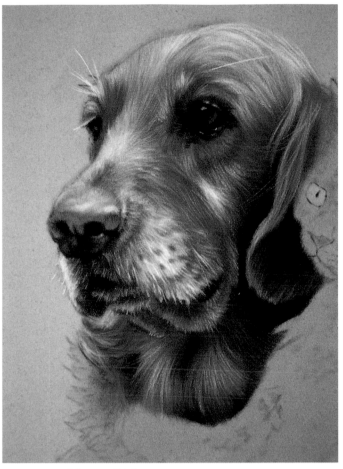

> **STEP 7:** *Start Adding Lights*

Use a sharpened light cream hard pastel to start stroking in the hair in the direction it grows. The good news is that hair directions are much the same on all dogs. Stroke in shorter hair in some places, like the muzzle and lips, and longer hair on other parts of the body.

> **STEP 8:** *Add More Lights*

Sharpen your white hard pastel and start adding white muzzle hair. This will make him look kind and old, sort of like humans when their hair starts turning gray, then white. Add some white to the nose, the top of the head and brow, and a highlight in the eye. I also put a tinge of blue there to soften the effect; this can read as a reflection from the sky and is not as shocking as bright white by itself. You want the dog to seem gentle, serene and aged.

> **STEP 9:** *Apply the Basecoat on the Cat*

If you didn't cover Bundy the cat in medium gray soft pastel when
you were working on Wally, do it now. He definitely is a candidate
for a gray undertone, since he's gray anyway. Leave his eyes the color
of the paper for now—you'll add gorgeous yellow-green eyes later.

> **STEP 10:** *Deepen the Grays*

Find the darker areas of the cat's face and fill them in with a dark gray
soft pastel. Remember, you're building a foundation for later so he
will have form and dimension.

> **STEP 11:** *Add Black*

Using a black soft pastel, go back over some of those dark grays and
take them a step darker. You'll want black in the ears, under the
neck—anywhere the light has the hardest time getting to.

➤ STEP 12: *Add Details*

Sharpen your black hard pastel and start
defining some of the details. Use the sharp
pastel edges to go around the cat's eyes, nose
and ears. While you're on the ears, find a nice
pinkish red hard pastel to add a little color.

➤ STEP 13: *Add Lights*

Use a sharpened pale gray hard pastel to
stroke in the hairs around the cat's face. Add
a few long wispy hairs in his ears, shorter
hairs on his face and long-flowing hairs on
his neck. Cats have a funny hair pattern on
their face, so make sure you get it all going
the direction it should.

➤ STEP 14: *Now for the Treats!*

Time to add yellow-green to the eyes. Don't
cats have the most gorgeous colored eyes?
Bundy sure does. Find a pale yellow-green
hard pastel and gently stroke in some color.
Use a very sharp black hard pastel or pencil
to put the slit line in as the pupil. When
there is a lot of light, cats only have a small
up and down slit. Then add a bit of light
highlight with a sharp light blue hard pastel
so he matches Bundy. They're side by side so
what we do for one animal, as far as light
source and colors, should be done for the
other.

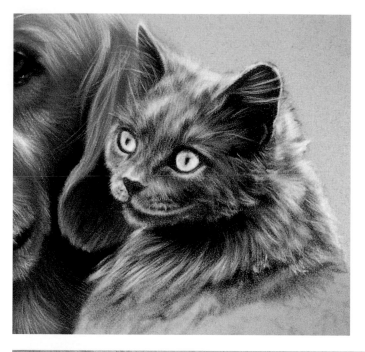

➤ STEP 15: *Add the Final Lights*

Make Bundy look really spiffy by adding
white highlights wherever needed on his fur
and in his eyes. Don't forget his whiskers!
Add them in with a very sharp pastel. It's a
real thrill to have the whole painting framed
and look at it and say "Oh no! I forgot the
whiskers!" Even more fun is to have someone
point it out after it's hanging in a gallery. I
could write a book about all the things *not* to
do, because I think I've done most of them
by now. I'm sure I'll still discover more as
time goes on.

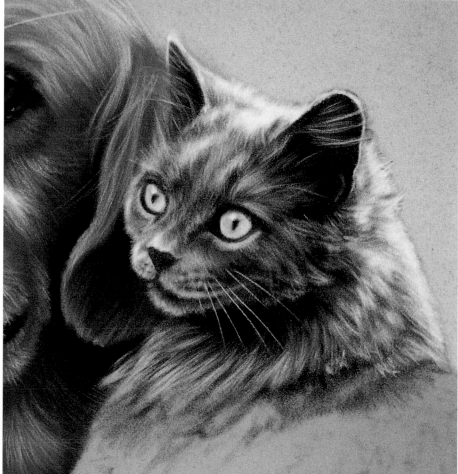

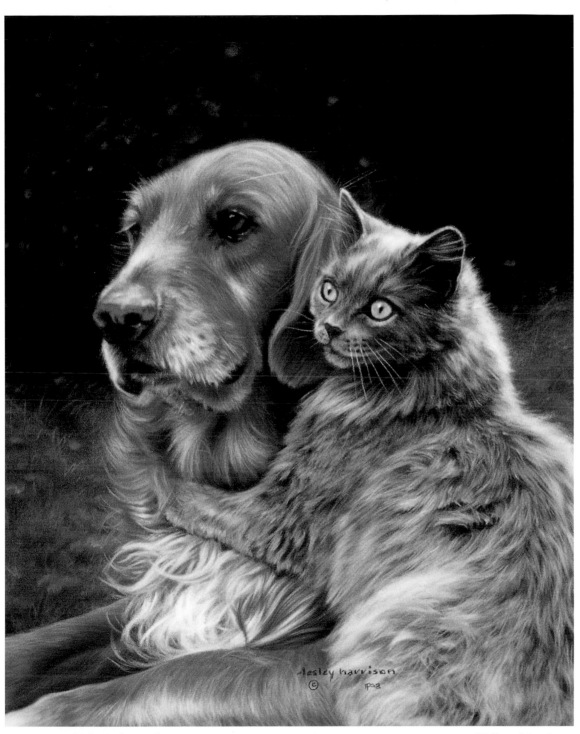

> **STEP 16:** *Add the Background*

So, what do you think? These guys are fun and I think they're pretty cute. Now see if you can finish them on your own using the same colors. Keep fur direction and length in mind as you work on the rest of the animals' bodies. Bundy has his arm around Wally, in case you haven't noticed.

Add in a soft, vague background using greens and pinks to represent a lawn or field with bushes or trees in the distance.

Wally and Bundy
Pastel on velour paper
14" × 11" (36cm × 28cm)
Private collection

Dog and Cat Gallery

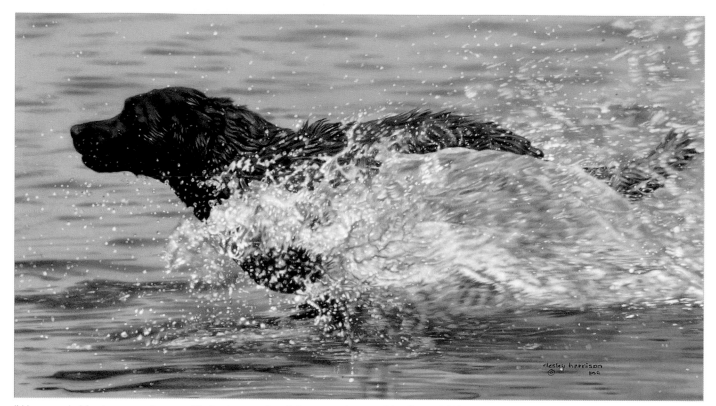

I'd been up in Montana, rounding up cattle for two weeks, all day, every day on a friend's ranch. We needed a break one day so we took two of their Labradors to the lake to take photos of them working with whistles and commands. I was amazed how well-trained they are and how they love what they do.

When I got my photographs back, I loved the water and the profile of the chocolate Lab in this one, so I painted it.

Making Waves
Pastel on velour paper
13" × 24" (33cm × 61cm)
Private collection

This is another of our cats, Jazzman. After a rough day of being encouraged to play with so very many props and toys so I could get good photographs, I found him in this clay pot, taking a break from his tough shooting schedule. I own this original, which is only one of two paintings that I just can't seem to part with. I have a client that's been waiting for three years, hoping I'll change my mind, but I just can't stand to sell this one.

Taking a Break
Pastel on velour paper
9" × 9" (23cm × 23cm)
Collection of the artist

Baby Animals

CHAPTER SIX ➤➤

What is it about baby animals that fascinates us so much? Is it how cute they are? Or is it that they have such a wonderful sense of play that we all seem to lose as adults, whether animal or human?

Baby animals have a wonderful freshness and innocence that can't help but appeal to anybody with a heart. And painting them, with their expressions and their funny little feathers or fur sticking out, is not only fun for the artist. It is also delightful to watch people's reactions to them as well.

Squirrel
Pastel on velour paper
14" × 10" (36cm × 25cm)
Private collection

103

Babies are so very different than their parents, and that's what makes them fun. Adults are usually sleek and pretty, while babies can be round and bumbling. All babies like to play, which helps prepare their reflexes and minds for survival later on.

Between their funny antics and their round, furry (or pin-feathered) looks, we love them because they make us smile or want to protect them in their naive state.

Reference Photo
Mountain lion cubs are blue eyed and have spots until they grow into adolescence.

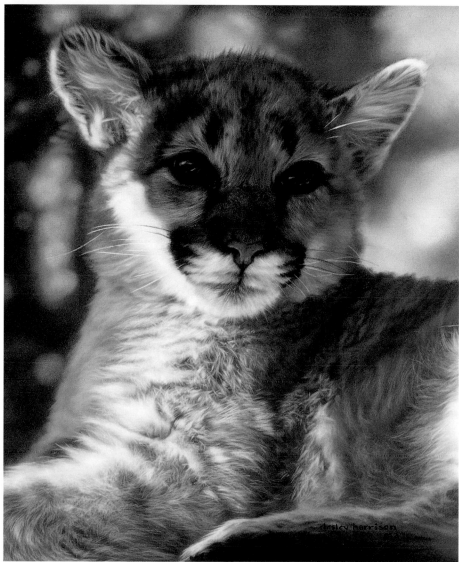

Innocence
Pastel on velour paper
16" × 12" (41cm × 30cm)
Private collection

Reference Photo
An adult mountain lion has amber eyes, no spots and is a powerful, beautiful cat.

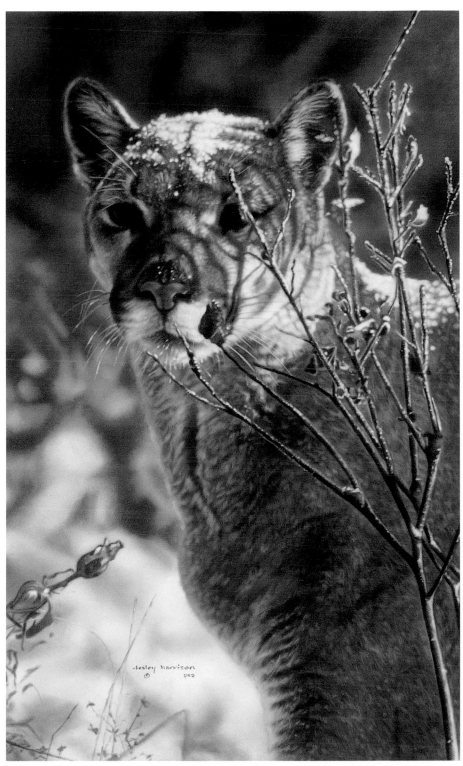

Watching
Pastel on velour paper
26" × 18" (66cm × 46cm)
Private collection

When I was single and could have any animal I wanted, I had a bunny. His name was Flower, because he was white with a few golden brown spots and one was around his eye in the shape of a flower. He had a weakness for cilantro and would sit up on the kitchen counter, holding his cilantro in his paws and eating it while I fixed dinner. We also ate cookies and watched TV together in the evenings. He was a great little buddy.

The bunny that you're going to paint for this demonstration is very young and very cute. You should enjoy this because bunnies are quite easy and fun to do.

MATERIALS

Paper
 Blue velour paper

Soft Pastels
 Dark golden brown
 Golden brown
 Gray

Hard Pastels
 Black
 Dark gray
 Light gray
 Orange
 White

> **STEP 1:** *Complete the Sketch*

I used a blue piece of velour but if you have a choice, use gray. I used blue because it was all I had left at my home studio at the time. There are ways to work with this problem and I'll show you in the next step.

 Sketch in the bunny with a sharpened black hard pastel. This is a simple sketch because bunnies are mostly round and furry.

> **STEP 2:** *Cover Him in Gray*

Here's where you fix the fact that you didn't have gray paper to start with. Use a gray soft pastel and cover his whole body, except the eyes, in gray. Voila! A gray bunny.

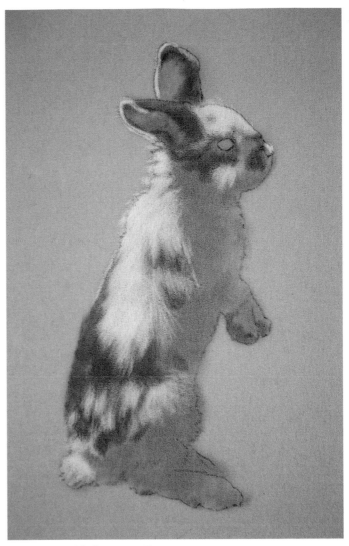

> **STEP 3:** *Add the Spots*

With a golden brown soft pastel, color in wherever his spots will be. He's mostly a white rabbit with some pretty brown spots on his ears, around the eye, muzzle, paws and back. Stroke in the direction the hair is growing, even this early in the painting.

> **STEP 4:** *Add the Main Coat*

Most of his body is white, so stroke in some white hard pastel directionally. Leave the shadowed areas of gray just as they are; you'll go in later and work that a bit more. Add white on his ears, forehead, tip of his nose, cheek, back, cute little tail and a little on his legs. The whitest white is where the sun is hitting him.

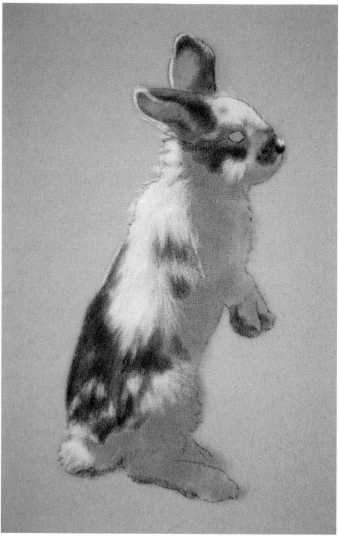

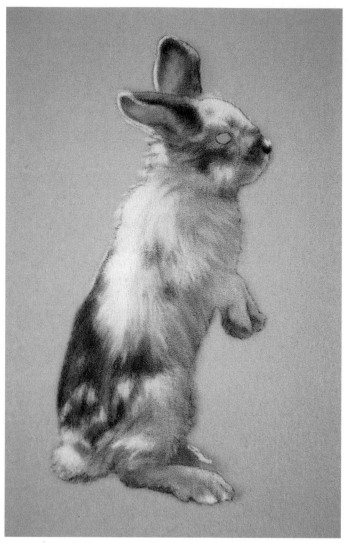

➤ **STEP 5:** *Deepen the Spots*

To make his spots richer looking, add some dark golden brown soft pastel to them. It will give him more dimension when you're finished.

➤ **STEP 6:** *Work on the Shadowed Areas*

Now, using a lighter gray and a darker gray than what we covered him with originally, go into the area in the shadow and use the light gray hard pastel for lighter hairs and the dark gray hard pastel to balance it all out. You want this to look shadowed but to have highlights with detail and dimension. Define his fur in the shadowed area, which means it will be a muted version of what you did on the rest of his body.

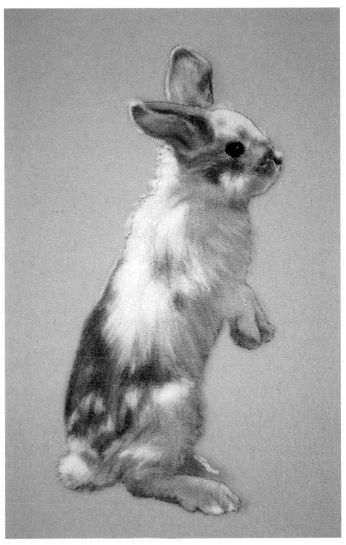

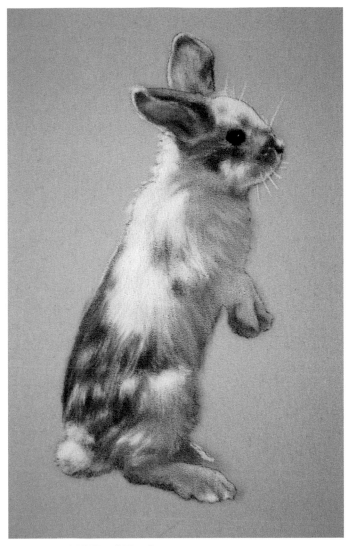

> **STEP 7:** *Work on the Eye and Ear*

The light is shining through the ear nearest you, so you need to show it. The light makes the ear semi-transparent and you actually see the veins in his ear. Use a dark orange hard pastel very judiciously for this. Veins are thin.

Using black, add the eye with a small white reflected spot on top of it.

> **STEP 8:** *Add Final Touches*

The finishing touches are the whiskers and light white on top of the brown spots to make them look more real. Sharpen your white hard pastel and use it for both.

Now all you have to do is figure out what kind of a background you'd like around him. I'm thinking of a field of flowers and maybe he's checking one out, since he is just a baby and not very tall at all.

Sea Otter Pup

To get good reference material of sea otters you need to be out in the water near them, or you need a very long lens on your camera. They are great fun to watch, especially the babies. I have never touched one, but our local aquarium has a sample of a pelt and it is so soft to touch. Otters have a large amount of hair per square inch to help keep them warm.

MATERIALS

Paper
Blue velour paper

Soft Pastels
Dark gray
Light brown

Hard Pastels
Black
Light gray
Reddish brown
White

➤ **STEP 1:** *Complete the Sketch*

Use a sharpened black hard pastel to sketch the otter on blue paper. I chose blue because of the water around him.

➤ **STEP 2:** *Apply the Basecoat*

Use a light brown soft pastel to fill in his face.

➤ STEP 3: *Define the Eye and the Hair*

Use your brown from step 2 to color in his eye. Because he's wet (and they always are), use a sharpened dark gray soft pastel to start defining different clumps of hair. Remember, the fur is very soft and very fine so don't get overly enthusiastic. Use the dark gray to create the pupil and the rim around his eye.

➤ STEP 4: *Add Depth*

Use your sharpened black hard pastel to fill in the shadows and make the sections of hair even more individual. Darken the pupil and the rim around the eye.

> **STEP 5:** *Add the Highlights and Details*

Use a very sharp light gray hard pastel to stroke in the hair highlights. Put a glisten of white in his eye and a spot of reddish brown hard pastel in the bottom of the eye to bring it to life. Add some highlights around his nose.

Last, but not least, add the whiskers with a very sharp light gray or white hard pastel. Isn't that a cute face? Exactly what we want!

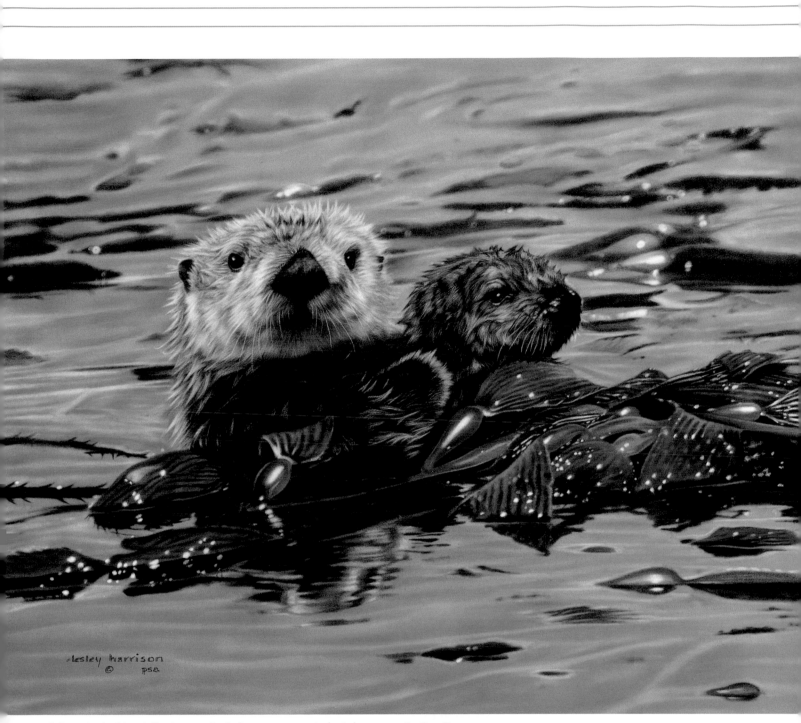

I chose to do this painting because both faces were so cute (not always the case). But the seaweed was what really intrigued me, because I had never painted any before and especially enjoyed the challenge.

In Our Care
Pastel on velour paper
16" × 20" (41cm × 51cm)
Private collection

A lot of baby animals have different fur or feathers than they will have as adults. Most of the time baby coats look messier and don't lay down as flat and pretty as adult coats. This little guy can't help but make you smile or laugh when you look at his face, with his hair standing straight up all over his body. In contrast, his mother has a long face and pretty sleek fur.

MATERIALS

Paper
Beige velour paper

Soft Pastels
Brownish gold
Medium gray
Pinkish rose

Hard Pastels
Black
Dark gray
Off-white
White

> STEP 1: *Complete the Sketch*

Use a sharpened black hard pastel to sketch in the baby and all the details you think you might need later. I have sketched in the two female lions because this cub is only a part of the finished painting.

Add white at this point to help figure out where it should be later in the painting process.

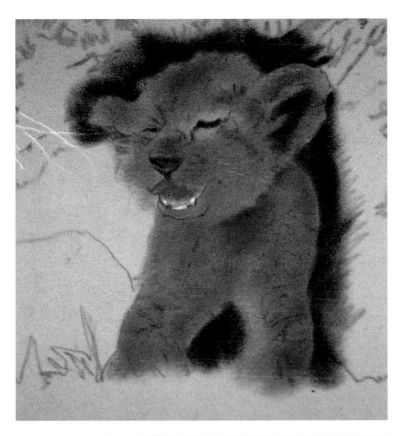

> **STEP 2:** *Begin Layering Color*

Lay in a basecoat of medium gray soft pastel
with a soft brownish gold over the top of it.

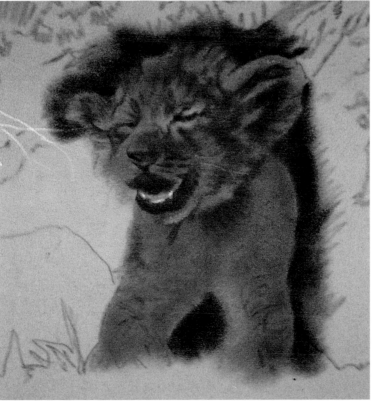

> **STEP 3:** *Add Dark Gray*

Using a dark gray hard pastel, work on his
ear and forehead, darkening anything that
needs it. I used a hard pastel because his little
face is only about three inches (8cm) across.
If yours is larger, use a larger pastel.

A WORD OF WARNING

Don't go out into the wild to try to get pho-
tographs of lion cubs. Their mama's job is to
protect them, and you don't want to get in
between her and her babies. There are many
wildlife centers, and a simple call ahead will
usually grant you permission to come in to
take some reference photographs.

➤ **STEP 4:** *Start on the Individual Hairs*

Sharpen an off-white hard pastel and start
putting in the individual hair on his face.
They don't necessarily all have to go in exact-
ly the same direction because babies haven't
figured out how to clean themselves and
sometimes Mama gets over-enthusiastic in
washing them. This causes the fur to go
every which way, and it's partly what makes
them so cute at this stage. Once you've added
the lights, use a black hard pastel to start
adding contrast.

➤ **STEP 5:** *Add the White*

As always, the last touches of white are what
make a painting come alive. Sharpen your
white hard pastel and add those last finishing
touches to his fur and see if that little face
doesn't make you smile too. Don't forget his
whiskers. Use a pinkish rose soft pastel for
the tongue color.

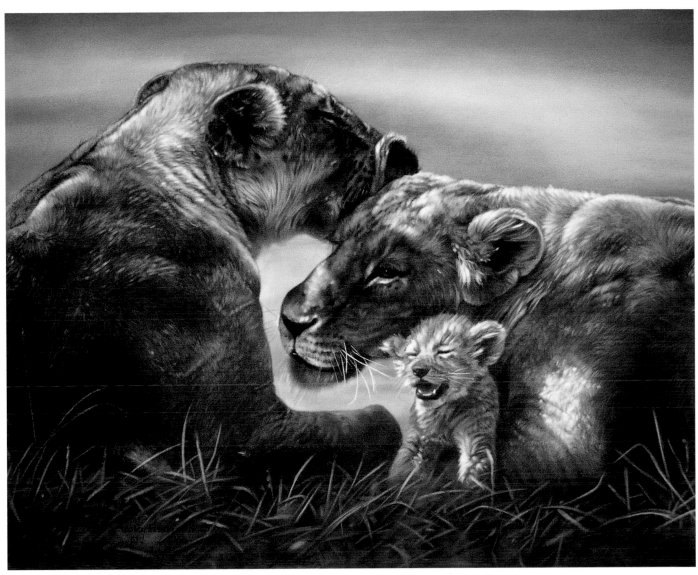

I fell in love with the expression on this cub's face. Doesn't he remind you of a domestic kitten who is unhappy about something?

African Lionesses With Cub
Pastel on velour paper
16" × 20" (41cm × 51cm)
Collection of artist

One spring I went to our local wildlife center to see what baby animals were there. There was a whole cage full of Canada geese goslings. I took two armloads of them outside and put them next to a small manmade pond. They went berserk! They got all wet and had so much fun running around and pecking at every little thing they could find. It was a delightful afternoon for all of us and I got some great reference photographs.

MATERIALS

Paper
Beige velour paper

Soft Pastels
Beige
Gold ochre
Green
Light gray
Light purple
Lime green
Yellow
Yellow-green

Hard Pastels
Black
Brownish gray
Dark gray
Light yellow
Medium gray
Reddish brown
White

➤ STEP 1: *Complete the Sketch*

Sketch in the gosling with a black hard pastel, using white to indicate areas you'll add to later.

➤ STEP 2: *Start Layering*

Apply a light basecoat of light gray soft pastel over his little body.

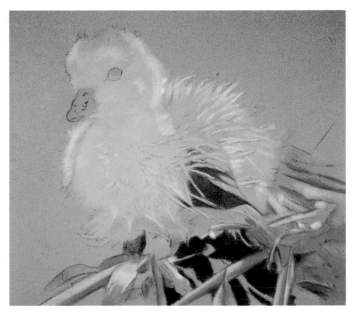

> **STEP 3:** *Add Color*

Lay down yellow soft pastel on top of the gray. Add white hard pastel again for placement so you won't go over where the white is to be later. This little guy had been playing in the water, so some of his brand-new feathers were stuck together. Using a light yellow hard pastel, show where those pin feathers will go so you don't lose some later. Use a dark gray hard pastel to loosely show where his wing will be.

Lightly add some green soft pastel where the reeds and grass will be later, using gold ochre and yellow- and lime-green soft pastels. Shadow some of the greens with a brownish gray hard pastel and dab some white highlights so you can find them easily later.

It's easier in the beginning to lay the basic colors in on all the parts of the painting at once. It seems to make the painting "read" better and helps solidify the composition.

> **STEP 4:** *Add a Background*

I have found it's best to start adding a background before spending too much energy putting detail into the main subject. Otherwise, you may smear the main subject later by trying to add the background last.

For this background use a light purple soft pastel with a little beige soft pastel over the top to represent soft-focused clouds against a blue sky. Our cute little guy is the main focus, so you can put your background in loosely if you like.

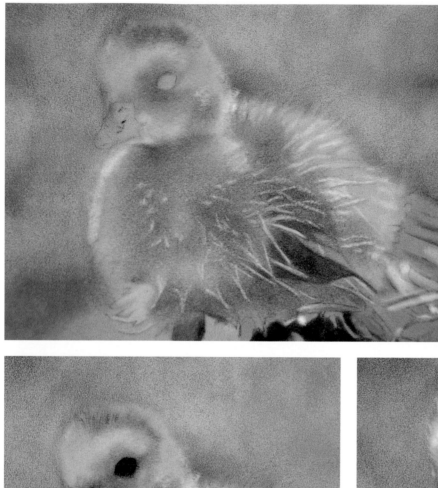

➤ **STEP 5:** *Start Adding the Detail*

Using a medium gray hard pastel, start adding your darks. Use a reddish brown hard pastel for tinting, with dark gray hard pastel on top of that.

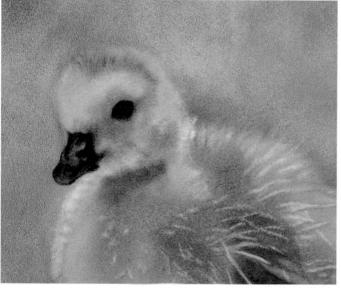

➤ **STEP 6:** *Work More on the Face*

Apply a base of dark gray hard pastel on his beak. Use the gray on the eye and top of the head, too. Add some light yellow hard pastel.

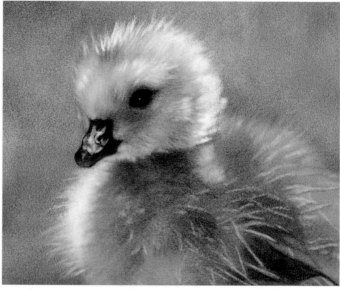

➤ **STEP 7:** *Add the Almighty White*

Now, get out your white and make this come alive with light! The gosling is backlit, so he'll have a halo of light around him. Use a sharpened white hard pastel to add details on his face. Remember, these are feathers (well, almost, he's still a baby) so the light is reflecting off of each one. We don't want blobs of loose white. Don't forget his beak and a reflection in his eye.

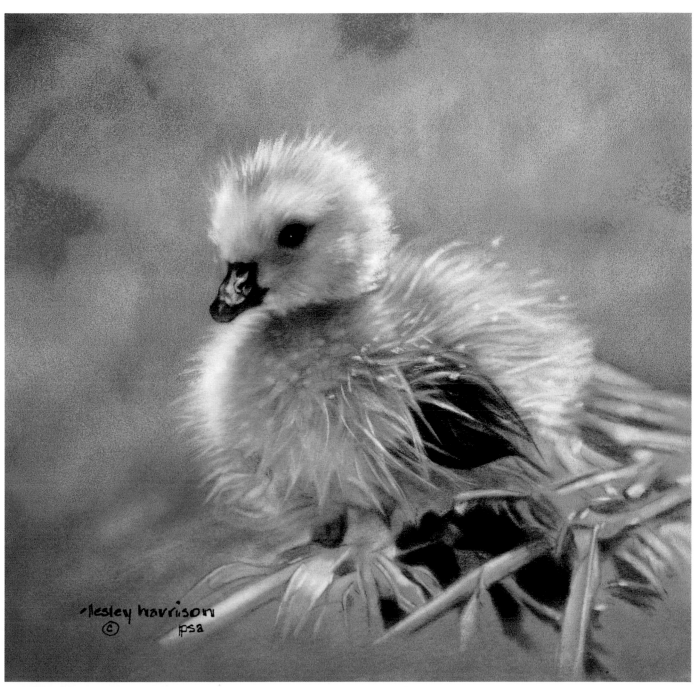

➤ STEP 8: *Pick up the Feathers*

Use a sharpened light yellow hard pastel to lift up the feathers so the viewer can see them separated from the rest of his body. Add in final strokes of white to highlight feathers on the back and side. Since this is flat work, the only way we can give it dimension is with the light.

New Feathers
Pastel on velour paper
8" × 8" (20cm × 20cm)
Collection of the artist

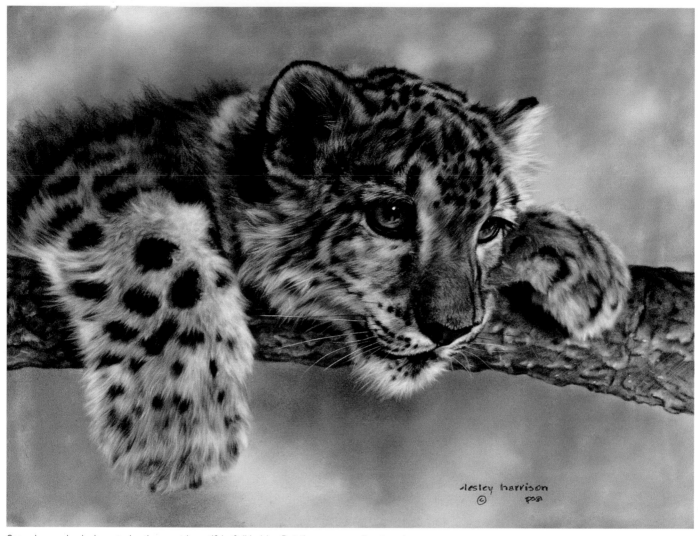

Snow leopard cubs have to be the most beautiful of all babies. But then, maybe I'm a little partial, since I got to watch this one (along with her sister) grow up into a majestic, very large cat. I have never painted them as adults, but did quite a few paintings when they were three to five months old.

Intrigued
Pastel on velour paper
11" × 14" (28cm × 36cm)
Private collection

I borrowed these two bunnies and a duckling from a local pet store to photograph them for reference material. As soon as I let them out of their box, they took off in different directions. I don't know where the duckling went. I had to add the petunias later because these bunnies didn't pose or wait around for me to get the perfect photograph.

Bunnies in Petunias
Pastel on velour paper
11" x 14" (28cm x 36cm)
Private collection

Baby horses are all legs, and within a few hours of being born can run and leap quite wonderfully.

Flower Child
Pastel on velour paper
16" × 20" (41cm × 51cm)
Private collection

One of the very charming and fun things about babies is their curiosity and playfulness. Two tiger cubs on the beach with waves coming in has endless and sometimes hilarious possibilities.

No, You Go First
Pastel on velour paper
12" × 20" (30cm × 51cm)
Private collection

Index

➤ A

African Lionesses With Cub, 117
African lions, 114-117
Against the Wall, 68

➤ B

Baby animals, 103
 African lion cub, 114-117
 African Lionesses With Cub, 117
 bunnies, 106-109, 123
 Bunnies in Petunias, 123
 Chasing Daisies, 26
 Contentment, 31
 Flower Child, 124
 gosling, 118-121
 horse, 124
 In Our Care, 113
 Innocence, 104
 Intrigued, 122
 New Feathers, 121
 No, You Go First, 125
 sea otter, 110-113
 snow leopard, 122
 Squirrel, 102, 103
 tiger cubs, 125
 vs. mature animals, 104-105
 Without a Care, 26
Background, 22, 23
Believability of subject, 26
Big cats, 29. *See also* Cats
 African lion cub, 114-117
 African Lionesses With Cub, 117
 aggressive hunter, 30
 Canadian lynx, 38-43
 caregiver, 31
 cheetah, 25
 Contentment, 31
 eyes, 32-33, 41
 Friends, 43
 fur, 36-37, 41
 Icy Whiskers, 28, 29
 Many Moons, 44
 mountain lions, 45, 104-105
 paws, 34-35
 snow leopards, 32-37, 122
 Tiger By the Tail, A, 30
 Tiger Running, 46-47
 tigers, 30, 46-47, 125
 Watching, 105
 Watching Clouds, 25

 whiskers, 42
 Willow, 2, 4
 Woodland Royalty, 45
Blower brush, 17
Bold and Beautiful, 66, 67
Bunnies, 106-109, 123
Bunnies in Petunias, 123

➤ C

Canadian lynx, 38-43
Cats, 83-85, 96-98. *See also* Big cats
 Dubious Friends, 69
 eyes, 90-91, 98
 hair, 97
 highlights, 87, 91, 98
 painting of, 96-99
 Precious Friends, 24
 Rural Route 2, 84
 Taking a Break, 101
 Wally and Bundy, 99
 whiskers, 86-87, 98
Chasing Daisies, 26
Cheetah, 25. *See also* Big Cats
Color, 24-25, 27
Composition of paintings, 20-23
 close-up view, 23
 minimize the background, 22
 traditional portrait, 20
 unusual angles, 21
 unusual background, 23
Contentment, 31

➤ D

Daisies, 26
Dogs, 82-85
 eyes, 88-89
 fur, 93-95
 highlights, 89
 Making Waves, 100
 No Dogs Allowed, 82, 83
 painting of, 92-95, 99
 Snow Flurries, 9
 Special Brand of Love, A, 85
 Wally and Bundy, 99
Dubious Friends, 69

➤ E

Ears, 52-53, 109
Emotions expressed in paintings, 11

Excalibur, 80
Exuberance, 23
Eyelashes, 23
Eyes
 big cat, 32-33, 41
 bunny, 109
 cat, 90-91, 98
 dog, 88-89
 horses, 21, 70-71, 76
 sea otter pup, 111-112
 wolf, 62

➤ F

Faces, 74-77, 120
Feathers, gosling, 120-121
Fixative, 16
Flower Child, 124
Friends, 43
Fur. *See also* Hair
 big cat, 36-37, 41
 dog, 93-95
 wolf, 56-57, 59

➤ G

Glorious Gray, 22
Gosling, 118-121

➤ H

Hair. *See also* Fur; Whiskers
 African lion cub, 116
 cat, 97
 dog, 93-95
 horse mane, 78-79
 sea otter, 110, 111
Highlights
 Canadian lynx, 40
 cat, 87, 91, 98
 dog, 89
 gosling, 121
 horses, 71, 73
 wolves, 55, 62, 63
Horses, 13, 67
 Against the Wall, 68
 baby, 124
 Bold and Beautiful, 66, 67
 Dubious Friends, 69
 Excalibur, 80
 Exuberance, 23
 Eyelashes, 23

eyes, 21, 70-71, 76
face, 74-77
Flower Child, 124
gentle giants, 69
Glorious Gray, 22
highlights, 71, 73
Kindness in His Eye, The, 21
legs, 72-73
Little Visitor, 81
mane, 78-79
Morgan Stallion, 20
My Two Loves, 5
Romantic, The, 10
Where Such Majesty, 12, 13
wild and powerful, 68

➤ I

Ice, 27
Icy Whiskers, 28, 29
In Our Care, 113
Influences on the author, 8
Innocence, 104
Intrigued, 122

➤ K

Kindness in His Eye, The, 21

➤ L

Learning from this book, 11
Legs of horses, 72-73
Lighting in the studio, 18
Lions. *See* Big cats
Little Visitor, 81

➤ M

Mailbox and kittens painting, 84
Making Waves, 100
Many Moons, 44
Masking tape, 17
Metric conversion chart, 4
Morgan Stallion, 20
Mountain lions, 45, 104-105
My Two Loves, 5

➤ N

New Feathers, 121
No Dogs Allowed, 82, 83
No, You Go First, 125

➤ O

Old Wolf Remembers…, The, 51
Overworking of eyes, 33

➤ P

Paper, 16, 17
Pastel card, 16
Pastels, 13-14
 defined, 15
 hard, 15, 16
 soft, 15, 16
Paws, 34-35, 54-55
Photographic references
 dog and cat, 92
 lion cubs, 115
 mountain lions, 104, 105
 taking good photos, 19
 wolves, 50, 58
Popsicle, 27
Precious Friends, 24
Puppies. *See* Dogs

➤ Q

Quiet Moment, A, 48, 49

➤ R

Razor blades for sharpening pencils, 17
Reference material, 19
Research of subject matter before painting, 19
Romantic, The, 10
Rural Route 2, 84

➤ S

Safety tips, 17
Sandpaper, 16
Sea otter pup, 110-113
Setup of the studio, 18
Sharpeners, 17
Snow Flurries, 9
Snow leopards, 32-37, 122
Special Brand of Love, A, 85
Squirrel, 102, 103
Story-telling, 11
Studio setup, 18

➤ T

Taking a Break, 101
Tender Moment, A, 64

Tiger By the Tail, A, 30
Tiger Running, 46-47
Tigers, 30, 46-47, 125
Time for Play, 51
Tools, 17
Toxicity of pigments, 17
Treat, 63

➤ V

Velour paper, 16

➤ W

Wally and Bundy, 99
Watching, 105
Watching Clouds, 25
Where Such Majesty, 12, 13
Whiskers. *See also* Hair
 Canadian lynx, 42
 cat, 86-87, 98
 sea otter pup, 112
Willow, 2, 4
Wolf Dreams…, And the, 65
Wolves, 49
 Chasing Daisies, 26
 ears, 52-53
 eyes, 62
 fur, 56-57, 59
 highlights, 55, 62, 63
 Old Wolf Remembers…, The, 51
 paws, 54-55
 Popsicle, 27
 as predators, 50
 Quiet Moment, A, 48, 49
 social system, 51
 Tender Moment, A, 64
 timber wolf at play, 58-63
 Time for Play, 51
 Treat, 63
 Without a Care, 26
 Wolf Dreams…, And the, 65
Woodland Royalty, 45

Learn how to create mysterious, atmospheric nature paintings! Whether rendering scales, feathers, sand or fog, dozens of mini-demos and step-by-step guidelines make each step easy. You'll learn to paint the trickiest of details with skill and style. A final, full-size demonstration, combining animals with their environment, focuses all of these lessons into one dynamic painting.

ISBN 1-58180-050-9, hardcover, 128 pages, #31842-K

Make your wildlife paintings stand apart from the herd by capturing the fine details that give your subjects that certain "spark" they need to come to life. Fifty step-by-step demonstrations show you how to make fur look thick, give feathers sheen, create the roughness of antlers and more!

ISBN 1-58180-177-7, paperback, 144 pages, #31937-K

Through step-by-step demonstrations and magnificent paintings, Patrick Seslar reveals how to turn oils, watercolors, acrylics or pastels into creatures with fur, feathers or scales. You'll find instructions for researching your subjects and their natural habitat, using light and color and capturing realistic animal textures.

ISBN 1-58180-086-X, paperback, 144 pages, #31686-K

Wolves and foxes are a source of endless artistic inspiration and wonder. Learn how to capture these beautiful creatures and their kin in their natural habitats. Twelve step-by-step mini demos and three full size demonstrations show you how, with invaluable techniques for rendering fur, eyes, musculature and other distinctive features.

ISBN 1-58180-051-7, paperback, 128 pages, #31839-K

These books and other fine North Light titles are available from your local art & craft retailer, bookstore, online supplier or by calling 1-800-289-0963.